IMAGES
*of America*

# ISLE ROYALE

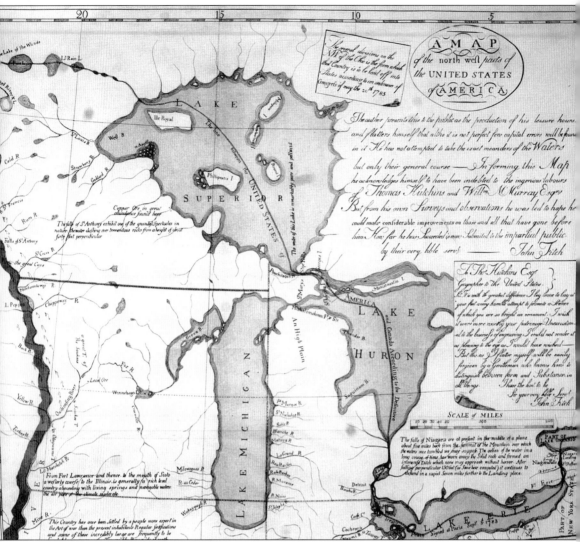

This 1783 John Fitch map from the post–Revolutionary War era shows how Benjamin Franklin managed through negotiation at the Treaty of Paris to acquire both Isle Royale and the eastern end of the Grand Portage in the treaty with Great Britain. It also shows that the early nation's maps of Lake Superior were poorer than much earlier maps made by the French (see page 18). (Marquette County History Museum.)

*On the cover*: Passengers wait to board the *Winyah* in the 1920s at a dock, possibly Rock Harbor. The *Winyah* was owned by the Christiansen family of Duluth, Minnesota, and was renamed in 1899. It was originally the steam yacht *Dungeness* built in 1894. It served as a yacht until 1924, then was significantly remodeled for Isle Royale service. In 1929, it began serving the route served by the *America*, which sunk off Washington Harbor in 1928. (Isle Royale National Park Archive.)

IMAGES
*of America*

# ISLE ROYALE

Jessica J. Poirier and Richard E. Taylor

ARCADIA
PUBLISHING

Published by Arcadia Publishing
Charleston SC, Chicago IL, Portsmouth NH, San Francisco CA

Printed in the United States of America

Library of Congress Catalog Card Number: 2007923217

For all general information contact Arcadia Publishing at:
Telephone 843-853-2070
Fax 843-853-0044
E-mail sales@arcadiapublishing.com
For customer service and orders:
Toll-Free 1-888-313-2665

Visit us on the Internet at www.arcadiapublishing.com

*To all the folks down through the centuries who have made the
wonderful fabric of Isle Royale history*

# CONTENTS

# ACKNOWLEDGMENTS

The authors would like to acknowledge the help of the many authors, agencies, and organizations whose help was needed to make this pictorial history of Isle Royale possible. Special thanks go first to Liz Valencia, chief of interpretation and cultural resources at Isle Royale National Park, whose hours of assistance were invaluable finding many photographs from the park archive that have never been in publication. Special thanks go to Erik Nordberg, director, and the staff of the Michigan Technological University Archives and Copper Country Historical Collections at Michigan Technological University; and Laura Jacobs, archivist at Jim Dan Hill Library, Great Lakes Maritime Collections, at the University of Wisconsin–Superior. Both of the previously mentioned archives provided invaluable images that helped to fill in the gaps of the rather sketchy photographic record of this wonderful island. Much of what happened there was not documented with cameras or even with pen and ink. Recognition also goes to Florence Bashaw, archivist at the Houghton County Historical Society, for all her help finding images. Jack Deo of Superior Views and Rosemary Michelin, librarian of the John M. Longyear Research Library at the Marquette County History Museum, also deserve recognition for their help with images for this book. We also think a trophy goes to our very patient editor, Anna Wilson, and publisher John Pearson from Arcadia Publishing.

We are sure our families know how grateful we are for their patience and support, but it cannot be said often enough. To Jessica Poirier's husband, Robert, thank you for taking the time to be our first editor, we needed your input. But more importantly, he was willing to be both Dad and Mom to their small boys, Elijah and Gabriel, during Jessica's long evenings working on this book. Elijah and Gabriel missed their mom's attention while she worked on photographs and writing and will hopefully develop a love for Isle Royale leading to island nature walks together. Isle Royale is a place without parallel in our country and the world, and we are proud to have a chance to share some of its rich history with our readers.

# INTRODUCTION

Isle Royale is located in the northwestern portion of Lake Superior and is truly a unique and remote island archipelago. To quote the National Park Service,

> Isle Royale National Park preserves 132,018 acres of land-based wilderness that was federally designated on October 20, 1976. The park consists of one large island surrounded by about 400 smaller islands; it encompasses a total area of 850 square miles including submerged land which extends 4 1/2 miles out into the largest fresh water lake in the world. Due to Isle Royale's biological and ecological uniqueness, it was designated an International Biosphere Reserve in 1980. These isolated islands have barely 20 species of mammals compared to over 40 found on the surrounding mainland. Some species have come and gone, often due to the influences of humans. The heavily forested shoreline of Isle Royale appears similar to the mainland's landscape prior to development. Gulls, ravens, and an occasional eagle or osprey dot the skies; squirrels, toads, mice, and spiders move about the forest floor.

Over 5,000 years ago, native copper was extracted from Isle Royale by the first human presence on the island. Anthropologists call these early miners Paleo-Indians. These first island visitors came from the northern Lake Superior shores of what is now Minnesota and Ontario. Using copper hooks, they fished Lake Superior's pristine waters for fat lake trout (called *siskwit* in Ojibwa), muskellunge, pike, and sturgeon. They hunted caribou, moose, deer, and wolves for hides and meat and gathered the native plants of the forests for sustenance. There is little evidence that they settled on the island permanently, but they made summer camps there that allowed them to mine the copper for both personal use and for trade. This commerce carried Isle Royale copper as far as the Gulf of Mexico and the cliff-dwelling peoples of the American Southwest. Even the mound-building culture of the huge Kahokia complex near St. Louis left extensive evidence of Isle Royale and Keweenaw copper in its grave sites. Due to forces no one really fully understands, the whole culture of these early miners collapsed. Knowledge of the copper and its handling and processing became the stuff of legend, related by the Ojibwa and Algonquin peoples who first met the white man in the 17th century.

The first westerners to come to the island were the French with their Jesuit missionaries and fur traders seeking to encourage their Ojibwa trading partners to trap fine pelts for the burgeoning market for fine felt hats in Europe. They also recorded the presence of native copper, and while they made no attempt to mine it, they piqued the interest of both the British and later the Americans. After the French and Indian Wars put the British-owned Hudson Bay Company solidly in charge of the fur trade, the same voyageurs plied the waters of "Lac Superieur," only

they worked for new British bosses. Isle Royale was an important stopover on canoe voyages that took these sturdy paddlers even farther west into Canada and what became the United States.

The extensive trading of both unworked copper and finished goods throughout North and Central America meant that settled villages and places for artisans to work were needed during these summer stays. Several sites around the island have yielded evidence of pottery and other items associated with village life.

Archaeological research both as a means to find native copper deposits and also for academic study has been going on almost as long as Europeans have been in North America. It was often evidence of hammerstones that was a clue to the location of a primitive mine. Hammerstones were used along with fire and water to break the rock holding the native copper.

Native copper was pounded by early coppersmiths into thin sheets and then folded and pounded again to make it thinner. Then a process called annealing, which heated the copper to 250 to 300 degrees centigrade, was applied. Chisels of annealed copper were used in combination with the stone hammers to extract the softer unworked copper from the rock or mass copper.

Quite often it has been found that the ancient miners opened a pit, then filled it in with the leftover rock called tailings. They even covered the evidence with sand and soil, perhaps to discourage "claim jumping" by others, possibly other tribal groups.

Stone scrapers suggest that the ancient miners remained on Isle Royale in the warmer months of the year and used them to prepare caribou and venison hides as well as meat that was likely dried and smoked. They also loaded their canoes with hide bags containing food and trade copper goods and headed for the mainland.

In spite of tools such as spear points found on Isle Royale, the island's use only in the summer is reinforced by the lack of burial sites or large village garbage piles called middens by archaeologists. In the 1860s and 1870s, the mine exploration destroyed much of this evidence, but the prospectors noted that they found some garbage evidence—bones of deer and caribou, and the scales of whitefish—in old mine workings.

The majority of copper pieces mined by the aboriginal miners were small, knocked out of seams of copper from one-quarter to one inch thick, with stone hammers or scaled off of large masses. Some of these pieces were big enough to be made directly into useful items, while others were not worked at all but carried to others for trade.

The peoples of the "old copper culture" of the Late Archaic period (1,000–200 BC) manufactured elegant conventional knives and also ulus (crescent-shaped knives with two hafts). Knives had wooden handles affixed to copper hafts or stalks and were used for scraping and cutting.

Like the Potawatomi cultures in historical times, these early people of Isle Royale mining days produced jewelry and beads for ornamentation. The beads were either discoid, tiny copper tubes, spiral tubes, or rings for ears or fingers.

In order to carry off usable copper from the masses and fissures of the metal they found, the archaeological evidence from Isle Royale shows three types of approaches. One was to hammer the copper into flat or curved strips. The curved strips could undoubtedly be more easily worked into jewelry and the flat strips into awls, punches, harpoon heads, or small knives.

Another form commonly found around the Isle Royale sites are termed "celts," which are masses of copper between 3 and 16 ounces that are worked into convenient sizes for fabrication of larger items such as axes, hammers, chisels, and spear points.

In their journals, compiled into *The Jesuit Relations*, the Jesuit fathers commented on all aspects of the areas where they ministered. They were the ones who opened new tribal contacts to trade in furs. While the beaver was the acknowledged king of this trade, there were many other animals whose skins were of value in European markets. The beaver was much admired for its industry to the degree that they were believed to have almost human intelligence. Beaver pelts were the primary source of hat felt from the 17th century through the 19th century.

Once the hides of the animals were prepared by smoking, scraping, and stretching to dry, they were taken to the trading posts or rendezvous points for barter. There Native Americans

obtained coveted goods such as steel knives, muskets, cloth, beads, trade silver, high-quality tobacco, and much more. Bartering at the trading post was often a raucous process with people of all types milling around in the confines of a log storehouse. A short paddle across the lake from Isle Royale, the post at Grand Portage was such a place.

The 40-foot Montreal class of birch bark canoe that was used on the Great Lakes during the 17th to 19th centuries could carry the weight of two compact cars—over two and a half tons or about 5,000 pounds. Called *canot de maitre* (mother of canoes), a 36-foot version was manned by 14 voyageurs. The canoes were so large that they required a bowman and stern man to rudder them about. There were two groups of voyageurs, the *mangeurs de lard* (pork eaters) and the *hivernants* (winterers). The hivernants paddled from the western interior to rendezvous at Grand Portage, and the mangeurs paddled the great canot de maitre from Montreal to Grand Portage. In the bow was the *avant* (bowsman). In the stern was the *gouvernail* (steersman), and along both sides were the *milieux* (middlemen). The milieux provided the horsepower and also hauled the majority of freight over the portages. The parcels were 90 pounds each, and a normal load was two per carry, or *portage*, (half-mile stopping point). They then ran back and got two more parcels. Also the bowsman and steersman were paid more than the middlemen.

At the beginning of the 19th century, the fledgling government of the new American nation sent explorers west to see what lay beyond the boundaries of the original 13 colonies. The popular view was that it was the country's manifest destiny to use the resources of this continent from coast to coast. It was on one of these journeys that Douglass Houghton, who was appointed Michigan's first state geologist, found signs of prehistoric mining on Isle Royale and the Keweenaw Peninsula near Copper Harbor, which sparked the first great mining boom in the history of the new nation in the early 1840s.

Mining did not turn out to be the productive enterprise on Isle Royale that it became on the Keweenaw Peninsula. Early settlers who came to mine or support the mining either left or turned to occupations such as commercial fishing, trapping, guiding wealthy sportsmen, lighthouse keeping and lifesaving, or "workin' the wrecks." Many people and their families lived either full-time or only during summers happily enjoying this wonderful island while pursuing their careers.

A real watershed in Isle Royale's history came in the 1930s with the onset of Great Depression, and through the ongoing efforts of dedicated conservationist and writer Ben East, and Alfred Stoll Jr., the outdoor editor of the *Detroit News*, the National Park Service took over Isle Royale officially in 1935 as a unique national park. Once funding became available in 1935 to buy out the residents and lodge owners, the new park plan brought an end to the resorts and the cottages that surrounded them. In an effort to return the island as much as possible to its pristine, natural state, many of the remaining cabins and fisheries were either closed and torn down or used by the park service. The original owners of a couple of the resorts went to work for the park, managing the new operations. After the lodges and cabins disappeared, the park service developed campgrounds and the Rock Harbor and Windigo lodge areas with the help of Civilian Conservation Corps workers during the Depression.

During the mining era, the rise of commercial fishing, the building of resorts, and a large number of transit shipping companies made Isle Royale a premier destination for "summer folk." After the advent of the national park, the nature of the choices for transport to the island changed. The island is now served by four ships, the largest of which is owned by the park service, and a seaplane. The story of these changes is captured here in pictures. The toll of the dangerous waters around the island that have taken lives from time immemorial is documented in the pictures of ships that foundered on the islands' shores.

The authors welcome readers to this intriguing story that begins long before recorded history and now features Isle Royale as one of the nation's and the world's finest wilderness parks.

# One

# GHOSTS OF
# THE ANCIENTS

Between 5,000 and 1,000 years ago, the peoples of the First Nations began to venture to Isle Royale to hunt caribou and to fish in its lakes and bays. Throughout the region as the postglacial climate changed, the people's lifestyles changed from the tundra hunters and gatherers of the late glacial period to a more settled lifestyle. Farming of maize and squash combined with fishing and hunting brought larger settled populations and the development of an artisan class that made better tools, bows, beads, and pottery. The demand of these settled people for jewelry, fishhooks, arrow and spear points, and tools drove demand for the native copper found on Isle Royale, the Keweenaw Peninsula, and the Ontonagon River basin. Mining of the copper was done by heating the rock with fire then splashing it with cold water, then it was broken out of the rock with stone hammers and wedges of the same metal. This copper was traded as far south as Illinois and the American Southeast. In Illinois, the remains of a mastodon (4000 BC) were found in association with a copper knife made of metal that came from the Lake Superior region. This definitely places the copper trade quite early after the end of the last ice age in what anthropologists call the Archaic period around 3000 BC. The early uses of Lake Superior copper were primarily utilitarian, but as time went on, uses became more decorative and ceremonial. Archaic period peoples created many varieties of projectile points, five known varieties of knives, nine known varieties of crescent-shaped knives (called ulus by the Eskimo people), four known varieties of hollow socket axes or adzes, solid axes and adzes, awls, punches, eyed needles, chisels, wedges, gouges, fishhooks, drills, harpoons, gaffs, spatulas, bracelets, and beads. In the more recent time of the Ohio Hopewell mound-building culture (200 BC to AD 400), the copper was used almost exclusively for ear spools, breastplates, ceremonial items, and jewelry. Some of the most unique items included deer antlers covered with hammered copper sheet, which when polished, undoubtedly shown bright in the sun.

In this view of a 1960s archaeological dig on the island, the researchers have opened up the site to determine the extent of the dig. The man kneeling is at the level of undisturbed bedrock and glacial sand next to an ancient mine pit, giving some perspective as to the size of these ancient mines. (Isle Royale National Park Archive.)

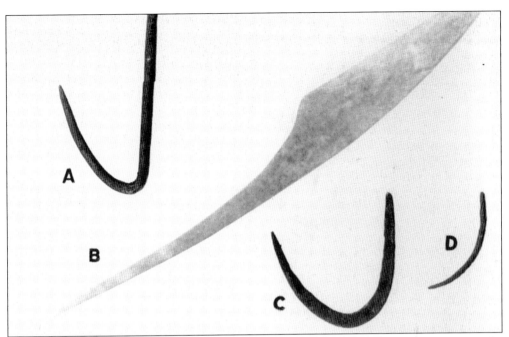

It appears that the early people of Isle Royale only made the island their home in warmer months as there simply was not enough game and climatic conditions were too harsh to sustain them over the winter. Pictured here are fishhooks and an awl made and used by them while on the island or possibly for trade. (Isle Royale National Park Archive.)

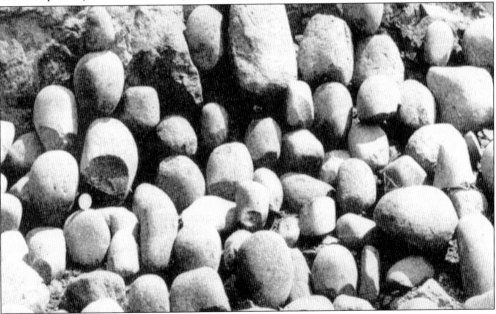

Quite often the hammerstones, like those above, were piled in large quantities near the pits where the ancient miners left them. They were shaped either as discs or in an elongated form and were likely found by the early miners on beaches. They were round or cylindrical-shaped basalt or granite cobbles formed by the action of the glaciers and the waters of Lake Superior. (W. H. Holmes for the Bureau of American Ethnology.)

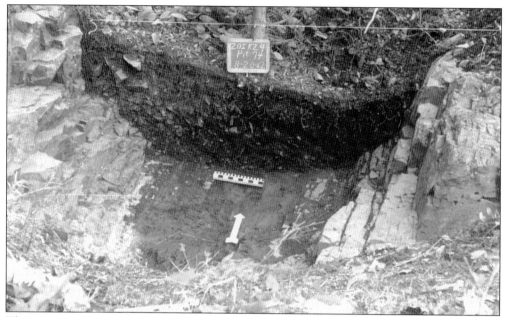

The ancient miners looked to find a vein of native copper at the surface of the ground. These native copper veins were often enclosed in a larger vein of calcite, a form of quartz, embedded in the surrounding hard igneous rock. In this photograph from a dig on a mine site, the calcite vein is at the bottom left of the pit where the miners left off their work. (Isle Royale National Park Archive.)

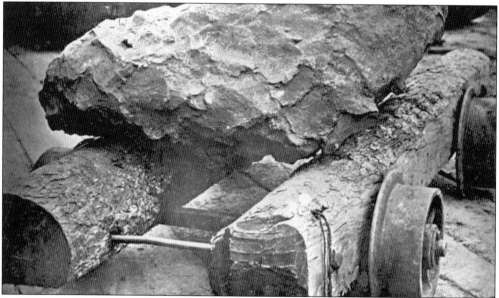

Exceptions to the effort to wrest small pieces of seam copper from the rock of Isle Royale appeared during the period of mining exploration in the 1800s. This copper mass of some 5,720 pounds was found on the Minong Mine property near McCargoe Cove in the 1870s. The ancient miners removed it from the bedrock by use of stone hammers and wood props, but it proved too difficult to move. (Michigan Technological University Archives and Copper Country Historical Collections.)

While most of the aboriginal mines were simple pits as above, some tunneling with proper timbering or use of natural rock support also appeared during the mining exploration of these workings in the 1800s. On the mainland, near the Minesota Mine in Rockland, Samuel Knapp discovered that ancient miners actually tunneled down below a six-ton mass of native copper supported on a crib work of wood and raised by only manpower and levers. (Isle Royale National Park Archive.)

Evidence here shows that the first miners of Isle Royale also smoked pipes for both pleasure and ceremonial purposes. It is very possible that they traded their red metal for plugs of tobacco from southern tribes and also smoked kinnikinnick, a naturally occurring wild plant; appropriately called "Indian tobacco." They also made weapons from other more traditional substances such as the slate projectile point pictured on the right. (Isle Royale National Park Archive.)

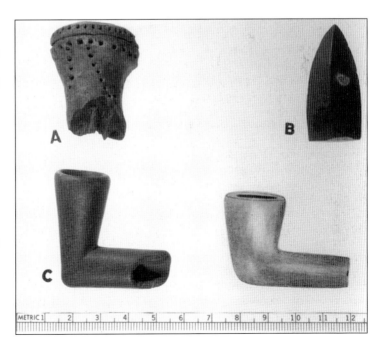

15

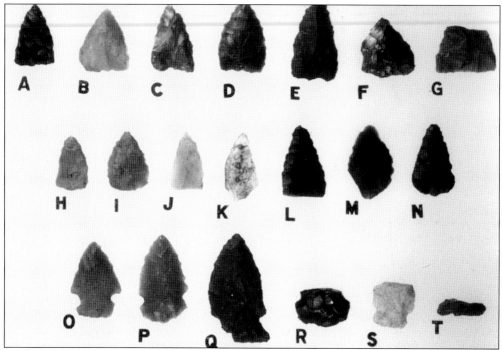

When looking at the work of the ancient miners, one must always remember that the majority of their work was essentially accomplished with Stone Age technology. While they mined, worked, and crafted useful implements from copper, they were still feeding themselves with arrow points of stone. Here is a cross section of projectile points of flint, taconite (iron ore), jasper, calcite, quartzite, and other stones found in association with the ancient mining sites. (Isle Royale National Park Archive.)

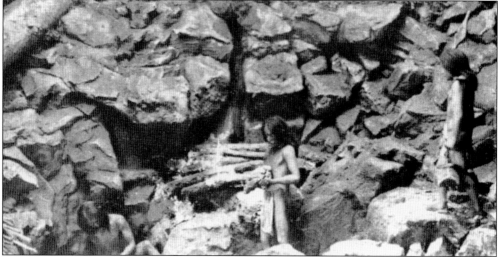

This artist's conception of the process of aboriginal copper mining on Isle Royale and throughout the Keweenaw Peninsula, the Ontonagon River valley, and northern Wisconsin is based on what the archaeological evidence states. It also shows how with simple Stone Age tools and with fire and water, these ingenious people tapped a resource that is valued to this day in the cultures of most eastern North American tribes. (Milwaukee Public Museum.)

# Two

# FATHERS AND VOYAGEURS

In the 17th century, French missionaries came to the Isle Royale area from the south. Soon after, French traders came from the east, around Montreal. The first Catholic missionaries were led by the Recollets Order in the first years of the 1600s (leaving very few records) and then by the Society of Jesus (Jesuits). In *The Jesuit Relations*, they carefully recorded the lifestyle and location of the First Nations and have given an extraordinary picture of customs, appearance, tribal conflicts, rivalries, wars, religious beliefs, food, and much more. Armed with this Jesuit "travel guide," explorers such as Samuel de Champlain, who sought the inside passage to China, and traders such as Pierre-Espirit Radisson and Médard Chouart des Groseilliers (who were brothers-in-law) arrived early on the scene. Champlain made his first journey to the Great Lakes in 1615 with the goal of finding the fabled passage to China and also to secure the French monopoly on the fur trade with the First Nations.

On the heels of these first missionaries, civilian workers came to New France to help build and sustain the missions such as those at Sault Ste. Marie and L'Anse on Keweenaw Bay. They were called the *donne*. Many of these men took brides from among the First Nations and their offspring, called metis, were often the ones who traveled west to the *pay en haut*, the far north, to trap and trade with peoples farther to the west beyond Isle Royale. The trade was carried on the backs and canoe paddles of voyageurs coming both from the far north and west and from Montreal by canoe. Those coming from the west carried furs to Grand Portage, and those from Montreal brought trade goods. Isle Royale became an important stopover point for the waterborne fur trade early in the game and remained so until the end of active trading in the mid-1800s. First the French, then the English and American companies, the Northwest and American Fur Trading Companies, relied on the calm bays of the island for shelter for their freight canoes and sailing ships and for respite from storms and even war.

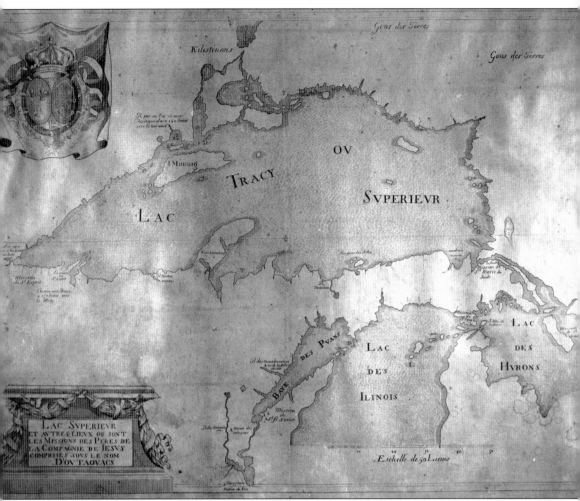

Another Jesuit map, dated 1679, shows a growing understanding of the true nature of the geography of the area in just 26 years after Samuel de Champlain traveled through this country. Both the missionary Fr. Claude-Jean Allouez and the explorer Jean Nicolet de Belleborne contributed to this growing knowledge. Notice the much more accurate portrayal of the Keweenaw Peninsula, Isle Royale, and the position of what is now Thunder Bay, Ontario, Canada. (Superior Views.)

When French missionaries, such as Fr. Claude Dablon, were sent to North America, it was their goal to save souls and at the same time to reconnoiter the country for the crown and church. Isle Royale was frequently mentioned in their travels and was always the "great island of copper, which the Savages believe is a home to Manitou or God." The famous Ontonagon boulder, pictured above, was also mentioned by the missionaries and worshiped by the Ottawa people. (*U.S. National Museum Annual Report 1895.*)

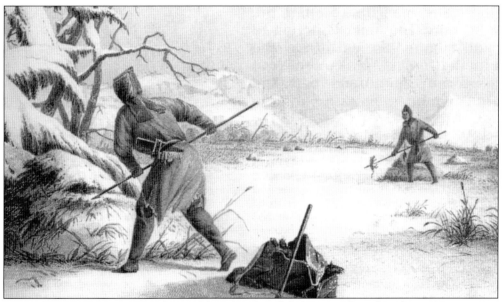

As the beaver trade grew, the demand for other furs did also, as reflected in this 1853 engraving from a watercolor by Seth Eastman of Native Americans spearing muskrats. A similar method was also used for capturing beaver and insured that the pelts were as unblemished as possible. (Wagstaff and Andrews.)

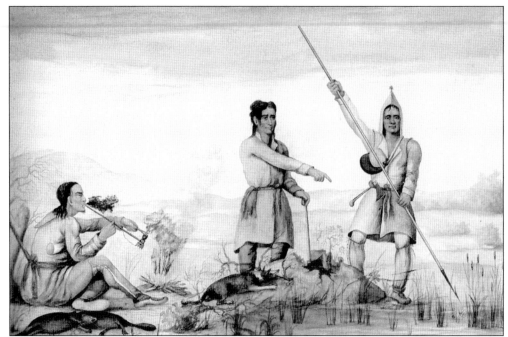

In this watercolor from 1830 to 1834 by Peter Rindsbacher, Canadian Indians are spearing beaver through the ice. The typical method for capturing beaver was for one man to break in the top of the lodge with an ax and the other to gig the beaver when they swam out of their lodge into a surrounding net, which was installed around the lodge just before freeze up. (State Historical Society of Wisconsin.)

There are no contemporary pictures of the great trading post at Grand Portage Bay (built in 1793). The National Park Service, working with many dedicated volunteers and academics in Minnesota, re-created the post. As the eastern end of the "great carrying place," Grand Portage Bay was also intimately connected to Isle Royale, where parties often stopped before traveling on to the rendezvous site. (National Park Service.)

Dr. Albert E. Foote, an assistant in the department of chemistry at the University of Michigan, undertook an expedition to the north shore of Isle Royale in 1867. He employed at least one *canot de maitre* (mother of canoes), as pictured here, and the services of voyageurs to get to his destination. He also sailed his boat the *Flying Cloud* as part of the expedition. (Michigan Technological University Archives and Copper Country Historical Collections.)

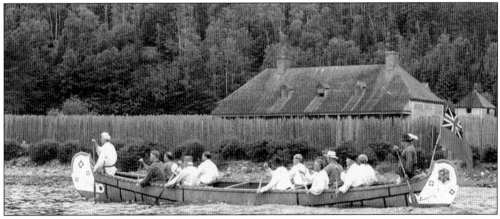

Reenactors from around the country come together every year to revisit the days when voyageurs from east and west came together across the narrow straits from Isle Royale. This group paddles its canot de maitre toward the pier at Grand Portage Bay. This is also the dock from which visitors to Isle Royale travel by way of the ferry *Voyageur* to the island. (National Park Service.)

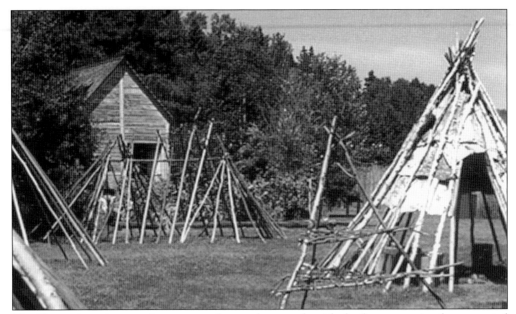

The Native Americans and voyageurs who sought to trade with the fur companies that occupied this post set up semipermanent camps often in tepees covered with birch bark as reproduced here. These were set up outside the palisades of the trading company offices, the great hall, but near the trade store in the background where items could be purchased, including tobacco, ammunition, and various other trade goods. (National Park Service.)

The American Fur Company found that what fur trade there was had gone north to the Hudson Bay Company after the Revolutionary War. As a result, it used Isle Royale as a fishing station. The fishing stations dried and packed barrels of herring, whitefish, and trout that were shipped east on schooners not unlike the one pictured here in dry dock. It operated several stations around the island with the main station at Hay Bay. (Michigan Technological University Archives and Copper Country Historical Collections.)

# Three

# COPPER BOOM AND BUST

From the time of the first European explorers, word of a vast copper island in Lake Superior had encouraged exploration. The historic mining record of Isle Royale is filled with stories of the giddy expectations of a mother lode and the disappointment of veins that simply "pinched out." The stories of great riches started with the fathers of France, the Jesuit missionaries, such as Fr. Claude-Jean Allouez and Fr. Claude Dablon, whose interviews with the Native Americans of the Ojibwa and others led to the drive to find the copper island. This information led to visits by French and British explorers to the island, the Keweenaw Peninsula, and the Ontonagon River valley.

In 1843, the first mining rush began on the island. There were essentially three periods of mining exploration and operation on Isle Royale: the early boom from 1843 to 1855, a revival period from 1873 to 1881, and the last flurry of activity from 1889 to 1893.

The first boom period was marked by the opening of mines around the discoveries of ancient mine sites at McCargoe Cove (Siskowit Mine), Snug Harbor (the Smithwick Mine), between Rock and Chippewa Harbors (the Ohio Mine and Isle Royale Mine), and Todd Harbor (the Pittsburg and Isle Royale Mines). The second mining period was between 1871 and 1883, with a mine again near McCargoe Cove (the Minong) and operations on the north of Siskiwit Bay (the Island Mine) and Conglomerate Bay south of Rock Harbor (the Saginaw Mine). The final period was of mine exploration only, as no significant mining took place. The Wendigo claim at Washington Harbor, which was run by the Isle Royale Land Company, bought land and mine interests that included the Minong Mine location (84,000 acres). With the prices of copper continuing to drop as cheaper copper ores in the American West and South America became available, the rock drilling and other exploration showed the ore values were not enough to make this last effort viable. The boom was finally a bust.

VIEW NEAR AN ANCIENT EXCAVATION.

Very little photographic record exists of the early mining operations on Isle Royale. As a result, one can only use engravings from sources contemporary to the period to get a feel for what mining was like for the miners on Isle Royale. In this 1853 lithograph, miners open an aboriginal mine site seeking masses of native copper these early miners could not remove. (Harper's New Monthly Magazine.)

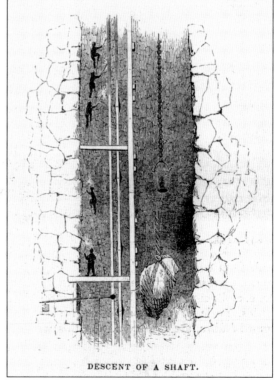

DESCENT OF A SHAFT.

Promising lodes were found and vertical shafts were dug by miners working on the tribute system. For example, they were paid $20 per foot dug but had to take all extra labor costs, supplies, tools, and, most importantly, candles. This engraving shows the common structures of early mining, wooden ladders for the miners and trammers to access the mine, and a whin (whim) line to raise a mass to the surface. (Harper's New Monthly Magazine.)

To surface both ore and waste rock from the mine tunnels, the Cornish kibble was used instead of a skip car for raising ore. The whim, a horse-powered windlass on the surface, raised and lowered the quarter-ton kibble loads. These started out being made of wood and then, as the mines developed, iron kibbles were put to work. Typically the iron kibbles handled between a half and three-quarters of a ton of rock. (Harper's New Monthly Magazine.)

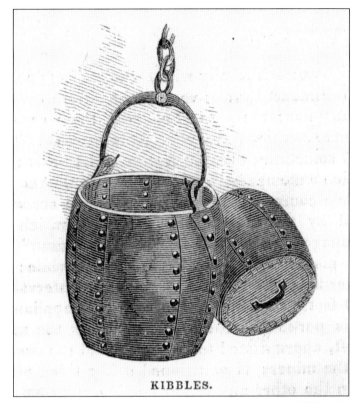

**KIBBLES.**

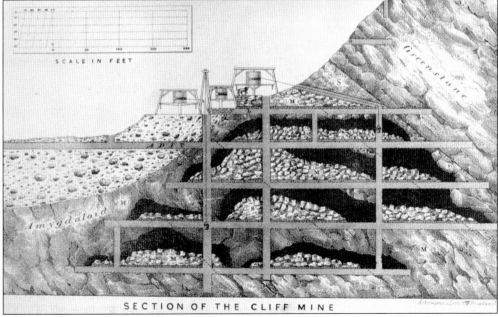

**SECTION OF THE CLIFF MINE**

This engraving of the Cliff Mine on the Keweenaw Peninsula shows the type of tunnel and shaft development that mines of the early period used. The whim (center) on the surface brings the rock up from adjacent tunnels, where miners blast out rock with hand-driven drills and black powder. (*Report of the Cliff Mine 1862.*)

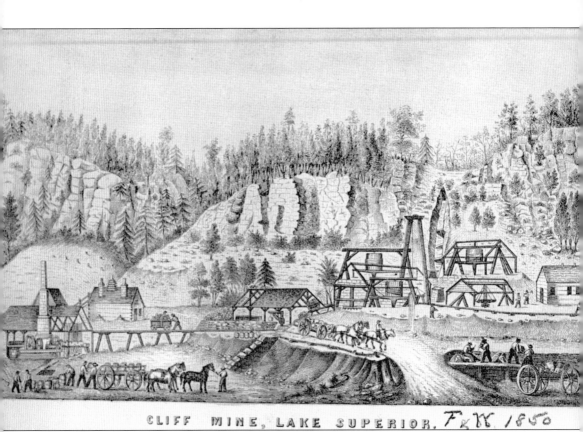

CLIFF MINE, LAKE SUPERIOR. *FξW 1850*

The Cliff Mine was one of the largest, most profitable, and longest operating of the mass copper mines of the early period in the Lake Superior region. This lithograph from the 1850s shows a typical surface plant including (from left to right) a Cornish gravity stamp mill, a blacksmith shop, a tram road from the shaft head, a breaker floor for breaking larger rock and removing masses, and the shaft heads with whims. (*Report on the Geology and Topography of a Portion of the Lake Superior Land District in the State of Michigan, 1850, Pt 1, Copper Lands.*)

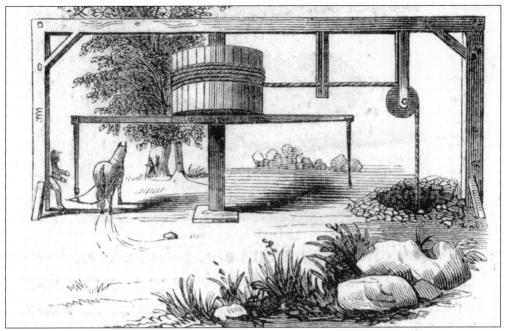

The main way copper ore was removed from the mine shaft in the early days before steam hoists was the whim, or whin, which required horsepower. This is why, in modern years, areas around old mine sites have fields such as Daisy Farm where alfalfa grows, a reminder of the horse and mule power of early mining. (Harper's New Monthly Magazine.)

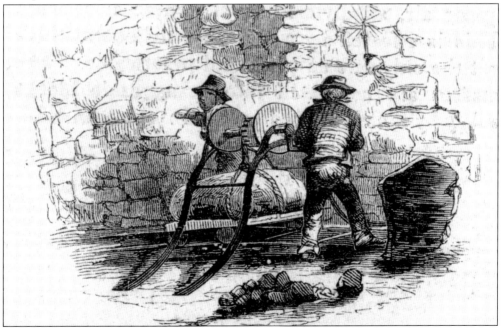

Underground, the copper masses had to be removed from the surrounding rock and then literally manhandled onto tramcars to get them to the vertical shaft where they could be lifted. Here the mine crew uses an iron armstrong lift winch that straddles the tram rails to place the mass on a tram cart. (Harper's New Monthly Magazine.)

As mentioned previously, kibbles of the very earliest mining operations on Isle Royale were undoubtedly wooden, like these pictured on the tailings pile at the old Delaware Mine on the Keweenaw Peninsula. Left to the ravages of nature, these early mining tools have fallen into states of decay and have turned to mulch and rust. (Photograph by J. T. Reeder; Michigan Technological University Archives and Copper Country Historical Collections.)

Here is the old poor-rock powerhouse of the Island Mine on Senter Point, located two and a half miles south of the mine site. Taken in January 1937, this picture shows how the forest was taking over the works of the miners and engineers. (Isle Royale National Park Archive.)

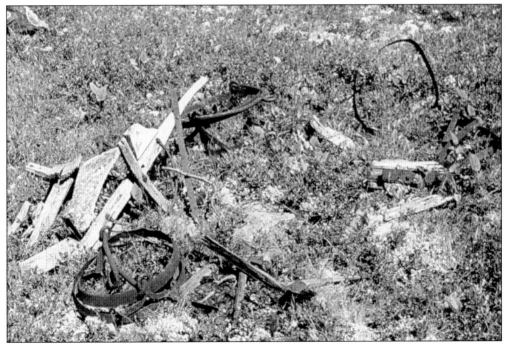

As time passes the items left behind by the miners eventually return to the earth. Here is what is left of mine buckets and carts at the Saginaw Mine site. The modern photograph was taken nearly a century after the mining operations ceased there. (Isle Royale National Park Archive.)

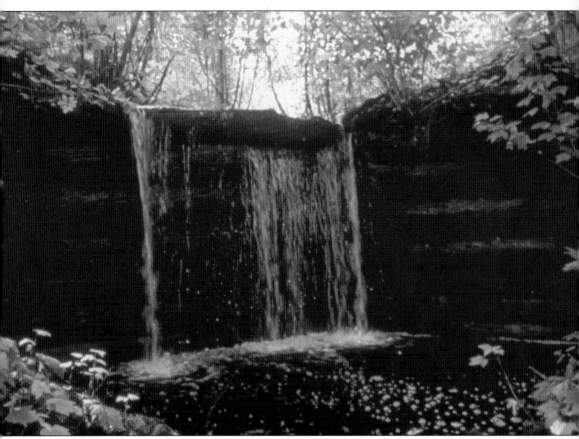

Even the constant flow of water takes more than 80 years to erode the workmanship of those men. Shown in this 1964 picture is the dam, built in the 1800s, for the stamp mill of the Minong Mine that is still standing. (Isle Royale National Park Archive.)

When this image was taken, the sunshine lamp mounted on miners' caps had become popular to light the blackness down below. The lamps place this group in the second era of mining, from 1873 to 1883. The sunshine lamp used a paraffin-like substance impregnated into a wick that was extended out of a cone-shaped reservoir and attached to the cap with a metal clip. (Michigan Technological University Archives and Copper Country Historical Collections.)

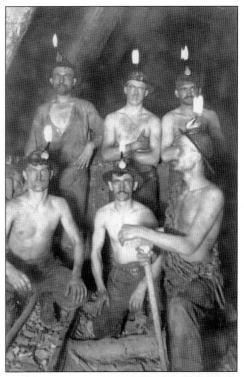

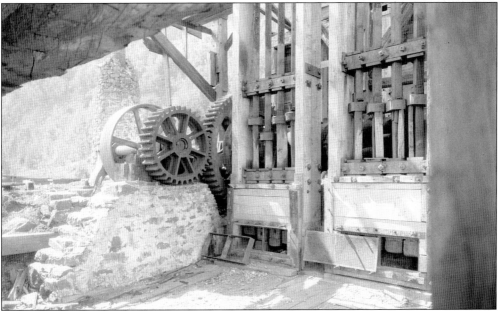

In a typical Cornish-style gravity stamp mill like this one at the Cliff Mine, the rock was loaded in from a hand-pushed tramcar at the top and then stamped in the battery of vertical stamps below. The crushed rock was washed from the bottom of the stamp, called the mortar, by a continuous flow of water. The crushed rock, called stamp sand, then traveled down the launders (wooden sluices) that were below the mortar. (Michigan Technological University Archives and Copper Country Historical Collections.)

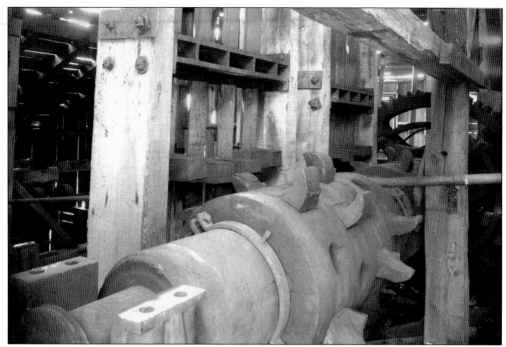

This Cornish stamp battery, photographed at the Central Mine, is identical to the batteries that once were located at the Siskowit Mine, which burned in the winter of 1852–1853. Note the heavy iron gears that were turned by waterpower to lift the stamp hammers with cam levers as shown. (Michigan Technological University Archives and Copper Country Historical Collections.)

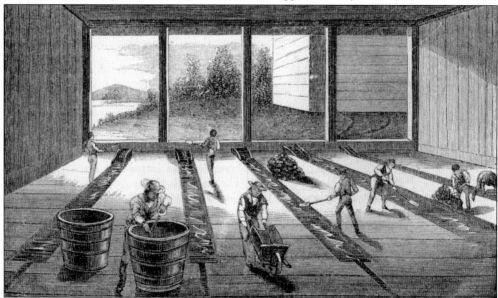

In the early years of mining, the process to separate copper from the fines, or stamp sand, that remained was essentially a hand process using a conical bucket called a verve and a separating floor, pictured in the lithograph above. The verve was filled with stamped ore and water, and the heavier metal settled out at the bottom. The Siskowit mill used this method until the complex burned in the 1850s. (Harper's New Monthly Magazine.)

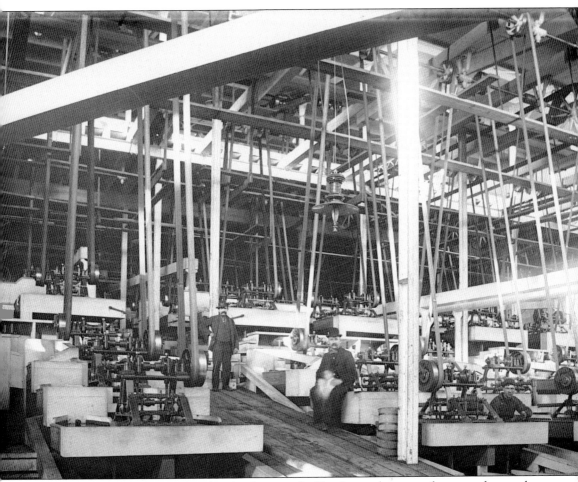

The middle period of mining on the island was marked by the employment of more modern tools for producing copper. Both the Minong and Island Mines turned out to be fairly productive until the late 1870s. The mines both had steam-powered stamp mills, steam-powered belt-driven jigs to replace the verves, and steam-powered hoists for accessing the mine. These jigs were located at Mason, on the Quincy Mining Company property at mill No. 1. (Michigan Technological University Archives and Copper Country Historical Collections.)

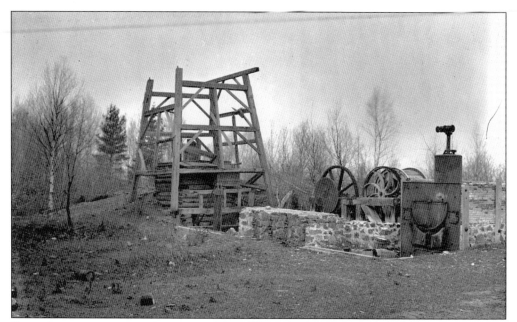

Steam-hoisting engines at the mines of the 1870s undoubtedly looked much like this one that operated on the Phoenix Mine. This mine operated in its heyday about the same time as the Island and Minong Mines. Like the mines on Isle Royale, the Phoenix shaft No. 13 was only a memory when this photograph was taken in 1915. Note the framing of the old vertical shaft. (Michigan Technological University Archives and Copper Country Historical Collections.)

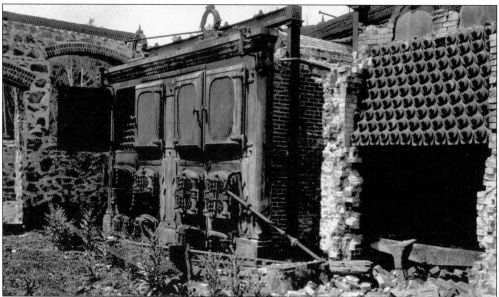

In order to provide steam for the various machinery of the mine and stamp mill, the Isle Royale mines needed multiple wood and, later, coal-fired boilers. This 1915 photograph shows an example of an old boiler from the Lac La Belle mill in the Keweenaw Peninsula and is contemporary with the mills of both the Island and Minong Mines. The ruin clearly shows the boiler tubes, or flues, in the right of this image. (Michigan Technological University Archives and Copper Country Historical Collections.)

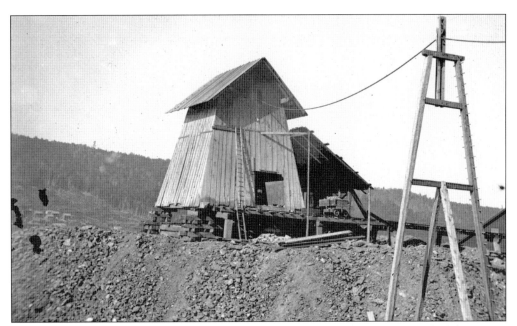

This picture of the old South Pewabic shaft house gives some impression of how shaft houses on the Island and Minong Mines may have looked. Note the cable coming from the right that was carried by pulley towers to the top front of the head frame that is enclosed in the building. At the floor level was a mechanism for dumping the skips into tramcars for transport to the stamp mill. (Michigan Technological University Archives and Copper Country Historical Collections.)

For a trip to the stamp mill, pieces of native copper, called barrel work, and larger masses of ore were broken up by hand on the upper level of the shaft house, or they were sent by tramcar to a rock house for processing. Finished ore was then sent through the "grizzly" on the right by shovel to insure it was right for the stamp mill. (Michigan Technological University Archives and Copper Country Historical Collections.)

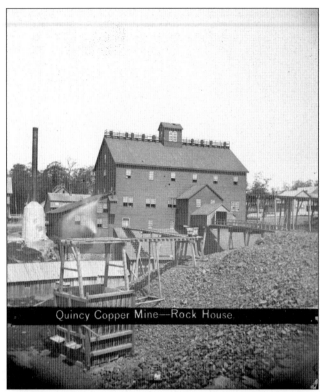

Quincy Copper Mine—Rock House.

Here is an early rock house of the Quincy Mine. This company also owned, through the North American Mineral Land Company, the tracts of land worked by the Minong Mine. These rock houses had grizzlies, steam-powered jawed rock breakers, and large shorting floors to separate the native copper from ore to be stamped. (Michigan Technological University Archives and Copper Country Historical Collections.)

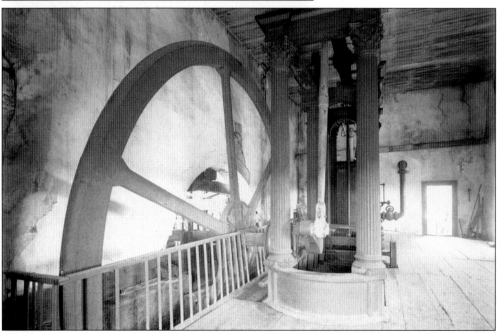

The steam engines that powered stamp mills required a large flywheel to insure even transmission of power to the stamp mills themselves via gears, cams, and belts. As time went on, newer stamp mills employed stamp engines that had their steam cylinders directly on the mill machinery. (Michigan Technological University Archives and Copper Country Historical Collections.)

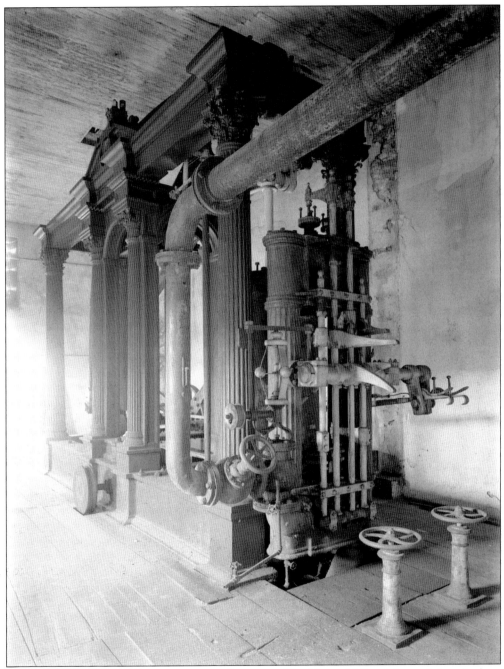

The other side of the 1866 steam stamp mill engine of the Central Mine (pictured above) sports fancy Corinthian-style ironwork and lavish brasswork. This photograph shows the vertical cylinder that converts the steam power into rotary motion. Engines such as this one were used to power the mills and pumps at both the Minong and Island Mines. (Michigan Technological University Archives.)

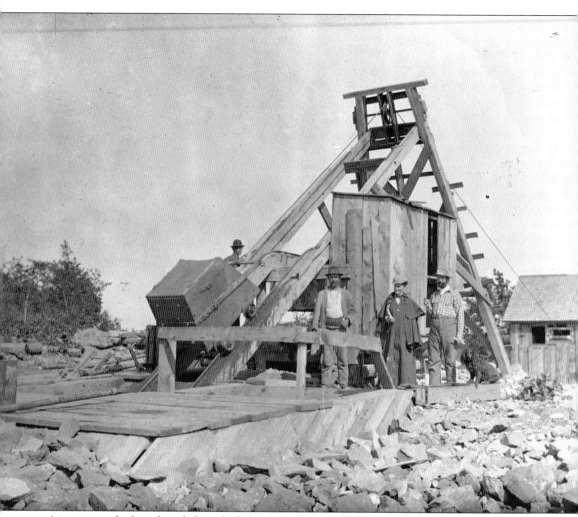

A primitive shaft and angled tracked skip from the Old Colony Mine could just as well be the primary shaft of the Island Mine, based on the contemporary practice. The men's attire fits the post–Civil War era, and the iron skip with steam winch cable places it in the second period (1870s) of mining on Isle Royale. (Michigan Technological University Archives and Copper Country Historical Collections.)

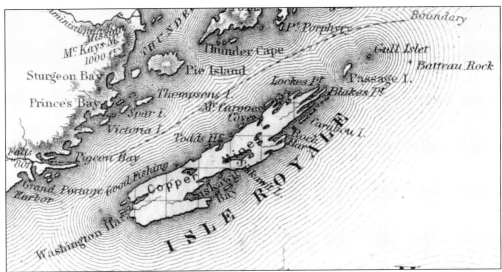

The Colton's Lake Superior map of 1872 shows the locations of some of Isle Royale's geographical features. This map dates from the middle mining period in the 1870s and shows the township lines but leaves out many details such as Feldtmann Lake, while it makes Washington Creek, north of the lake, look like a major river. Mapmaking at this period was purely based on observation and the art of the surveyor. Notice how the map represents Siskiwit Lake as farther inland than it actually is located. In reality, the lake is only separated from the bay by an isthmus of land less than a mile across. This map shows how weak on details the popular maps of the era were. If the charts were as accurate it is no wonder ships went aground so frequently. (Superior Views.)

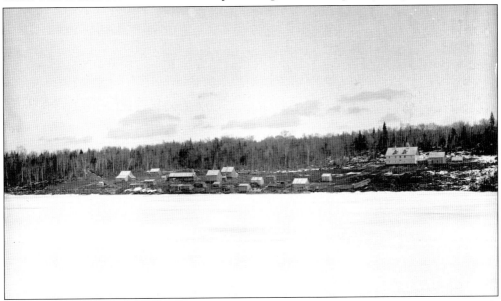

The picture above was taken in winter, from the ice on the harbor of the village of Ghyllbank, which was built to support the unsuccessful operations at Wendigo Mine. It was historically the island's most elaborate town site and included a large two-story office building and a large number of storage buildings and warehouses that paralleled the shoreline. At its peak, the town had a population of 135. (Michigan Technological University Archives and Copper Country Historical Collections.)

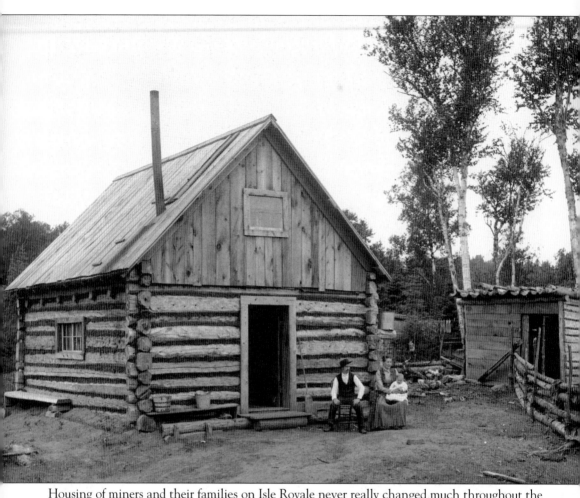

Housing of miners and their families on Isle Royale never really changed much throughout the entire mining era. The island's mining camps were the most primitive of the region, relying on the logs harvested from the island for the primary building material. A miner and his family, pictured here outside their Wendigo Mining Company house in the last era of mining operations in the 1890s, shows the typical living conditions. (Michigan Technological University Archives and Copper Country Historical Collections.)

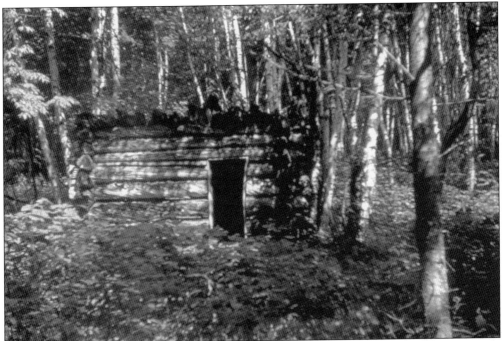

The cabin seen here has withstood many harsh Isle Royale winters. It is a testament to the workmanship of the men who came to Isle Royale in search of copper. (Isle Royale National Park Archive.)

It is almost as though the miners just walked away at the end of the shift, planning to return tomorrow and get back to work. In this 1976 photograph near the site of the Minong Mine, only the rusted metal remains, just as the miners left it back in the late 1800s. (Isle Royale National Park Archive.)

The old mines and miners are not forgotten on Isle Royale. In this 1925 picture, one can still see the path of the Siskowit Mine Road, even though mining operations there were abandoned about 75 years earlier. (Isle Royale National Park Archive.)

In this 1925 picture, another old mining road is visible as it fades into the forest. One can almost smell the wildflowers as their growth overtakes the road traveled so many years ago. (Isle Royale National Park Archive.)

42

# Four

# LIGHTS IN THE NIGHT

From the time of the Native Americans and the voyageurs until the sinking of the SS *Edmund Fitzgerald* in 1975, Lake Superior continued to prove that it was both kind and cruel. The lake and its basin provided great wealth in metals, timber, and fisheries but has also taken more lives than any of the other Great Lakes. The sudden fogs, white squalls, and terrible ice storms of spring and fall make navigating treacherous at best. Almost as soon as the mining era began, the government saw the need for lighthouses around Lake Superior shores, and Isle Royale was no exception. Lighthouses at Rock Harbor, Passage Island, Rock of Ages, and Menagerie Island have all served to warn passing ships and those bound for the island of the dangerous shallow rock reefs that ring its shores and bays.

During the administration of George Washington, all the light stations on the shores of the country were placed under direct federal control through the U.S. Lighthouse Establishment, enacted as the ninth act of the Congress in 1789 and controlled and funded by the secretary of the treasury. However, by the time of the Civil War the entire Great Lakes network was placed under the control of the U.S. Lighthouse Board, which was established in 1852. With the opening of the locks at Sault Ste Marie and the shipping of iron and copper ores from the western end of Lake Superior, the need for a network of light stations on Lake Superior was evident. It took until 1908 with the light at Rock of Ages before all the Isle Royale lights that are now in service became active.

Not only were these lights remote, but they were also exposed to some of the worst weather that the lake could dish up. The keepers, such as the John Henry Malone family of the Isle Royale (Menagerie Island) Light from 1879 to 1912, were as hardy and unique as their light stations. Malone and his wife had numerous children on the island, and the children kept a true menagerie of animals.

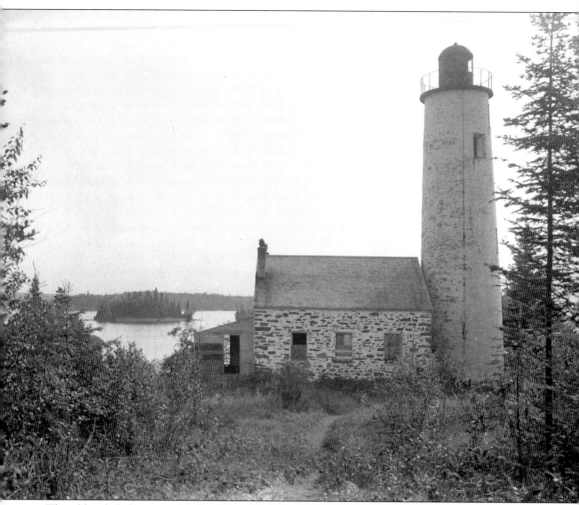

The oldest lighthouse on Isle Royale is Rock Harbor Light. Built in 1852, with its tower having been completed in its current form in 1855, it is constructed of rubble stone from the surrounding Smithwick and Pittsburg and Isle Royale Mines. The keeper quarters were attached to the tower directly. Shown in this photograph is a shed-style summer kitchen of frame construction, which has been removed since the photograph was made. The lighthouse closed in 1879. (Michigan Technological University Archives and Copper Country Historical Collections.)

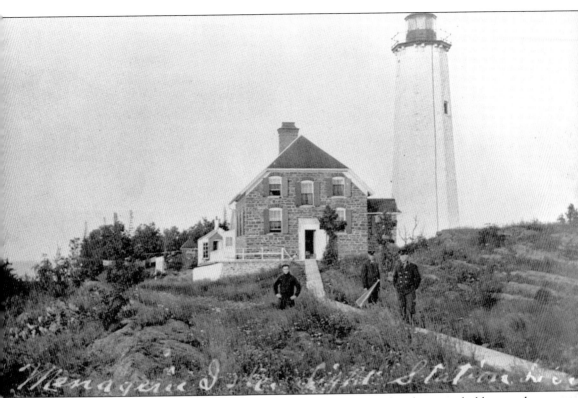

Menagerie Island, or Isle Royale, Light was established in 1875 and is the second-oldest on the island. The light is still active although it is entirely automated. The keeper's quarters, which is a two-story brick structure, is attached to the octagonal light tower. It was equipped with a fourth-order Fresnel lens that threw a bright beam of light 20 miles out on the lake. (Michigan Technological University Archives and Copper Country Historical Collections.)

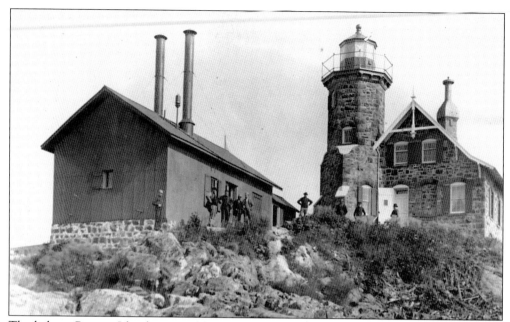

The light at Passage Island was established in 1882. It is still functioning as an automated aid to navigation. Its fourth-order Fresnel lens is on display today in the U.S. Coast Guard Station Portage lobby in Dollar Bay. The building was constructed of fieldstone, and the light tower is octagonal. There is also a fog signal building on the site with a reed-horn fog signal. The keeper's quarters is one and a half stories tall. (Isle Royale National Park Archive.)

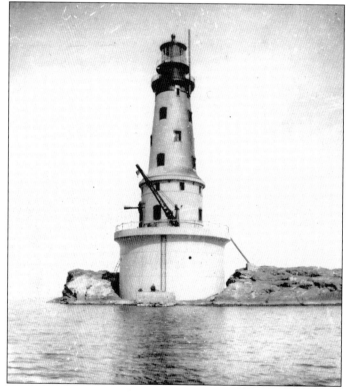

The Rock of Ages Light is the newest of the Isle Royale lights and is, like the Stannard Rock Light, a major engineering feat. Built in 1909, the light station is fully self-contained with a cylindrical, bottle-shape light tower that is 117 feet high. It used to sport a second-order Fresnel lens but now has an automated beacon. The original lens is on display at the Windigo visitors' center at Isle Royale National Park. (Isle Royale National Park Archive.)

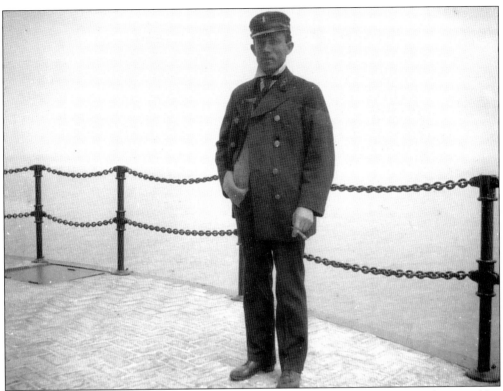

This Rock of Ages keeper takes time out of his duties to pose for a picture on the top of his lighthouse in 1910. With the fog rolling in behind him, one can only imagine he had a long day ahead of him. (Isle Royale National Park Archive.)

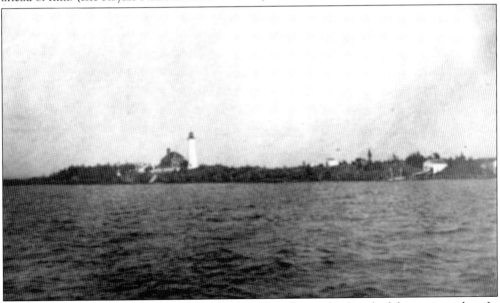

Menagerie Island is a rather long slip of land but less than a few hundred feet at its widest. In this picture from 1904, it is clear that it was a very exposed posting for a light keeper. (Isle Royale National Park Archive.)

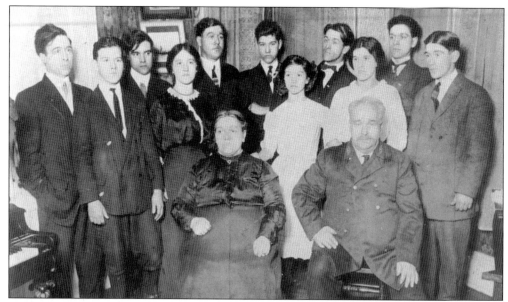

John Henry Malone and his family were quite an interesting crew. Here is the whole family in Superior, Wisconsin, around 1914. From left to right are (first row) mother Julia (1845–1936) and father John Henry (1845–1928); (second row) Charles (1882–1958), Reed (1888–?), Frank (1887–1961), Belle (1887–1964), John Albert (Al) (1881–1947), Folger (1897–1971), Dora Dorothy (1900–1971), Edward (1885–1950), Hester (1891–?), Sterling (1892–1942), and Carl (1894–1946). Another child died at birth. (Isle Royale National Park Archive.)

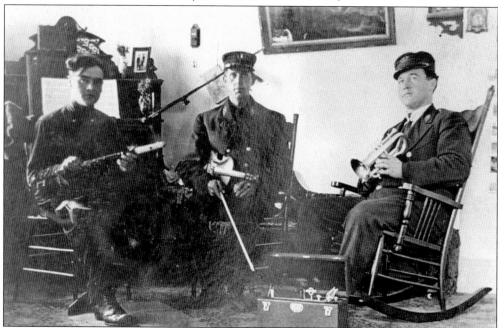

Entertainment in the pre–broadcast media days was a test of creativity and talent for light keepers and their families. Several members of the Malone family were instrumentalists. Seen here, from left to right, are Frank (on the clarinet), Sterling (with the fiddle), and Al Malone (on the cornet) in their uniforms tuning up to play. (Isle Royale National Park Archive.)

Lighthouse keepers quite often passed down their duties to relatives, either sons or brothers, and sometimes female relatives as well. Relatives apprenticed as assistant keepers and then assumed the role when the senior keeper retired. Al Malone took over for his father from 1910 to 1912 after serving as assistant from 1900 to 1910. Here he drives their motor launch with an unidentified boy at the stern of the boat. (Isle Royale National Park Archive.)

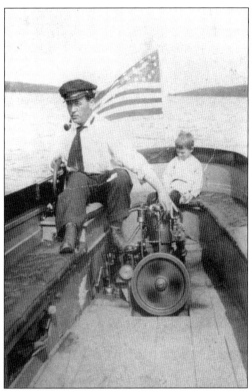

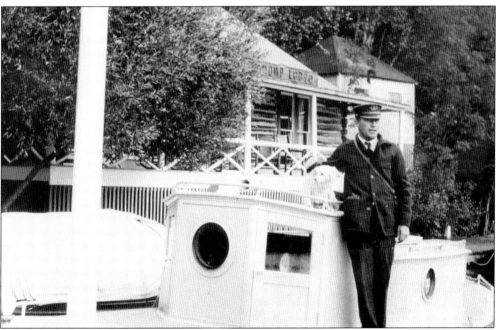

It is quite likely that the handsome and dapper light keeper of Passage Island made quite an impression on the ladies at Tobin Harbor (Minong Lodge) when he arrived in his uniform. The light keeper, his trusty dog, and their boat look quite, in a sailor's terminology, "ship shape and Bristol" as they pose for the photographer. (Isle Royale National Park Archive.)

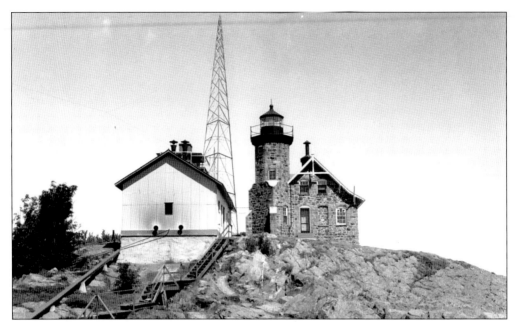

The Passage Island Light was the first and only light station to be equipped with shortwave radio and one of two stations—the other being the Island House Resort at Washington Harbor on the opposite end of the island. This 1938 photograph also shows that the fog signal building has lost the stacks for its steam-power generating plant as the signal was converted to a gasoline-powered generator. (Isle Royale National Park Archive.)

A lighthouse keeper had two main duties, keep the light burning through the fog and the storms and try to rescue sailors in peril when their ships ran aground. In 1940, the keeper at the Passage Island Light had this boat to use during those lifesaving missions. (Isle Royale National Park Archive.)

# *Five*

# SUMMER FOLK

Leisure pursuits and recreation have been a part of mankind's use and inhabitation of Isle Royale for 3,500 years. The Ojibwa people used the maple forests to make maple sugar candies in the shape of animals and mythic creatures. Anglo-American recreational activities have been going on for at least 140 years and are the primary use of the island today. Only the nature of the use patterns has changed.

As early as the 1860s, well-heeled visitors were brought to the shores of Isle Royale on large, sumptuously appointed, side-wheel steamers such as the *Keweenaw*, equipped with fabulous food and even brass bands. The elite of Detroit, Chicago, Cleveland, and other major Midwest cities were treated to visits to mining camps, fishing for trout in the bays around the island, and views of the rocky coast. By about 1900, the island was dotted by resorts and sporting clubs in places such as Washington Island, Belle Island, Minong Island, and more. All resorts from the early years on depended on the visits of ships such as the steamship SS *America*, which visited the island until 1928, when it sank after running aground. The Tobin Harbor and Rock Harbor lodges, founded by the Mattson and Johnson families, had the greatest traffic of all the resorts on the island due to the immense summer cottager colonies that grew up around them. In the early 20th century, other resorts and private clubs were begun by wealthy industrialists from Duluth such as the Washington Harbor Club in 1902, and shipping magnates such as Capt. William H. Singer, owner of the Lake Michigan and Lake Superior Transportation Company, who founded the Island House Resort in 1902.

All the resorts on Isle Royale suffered from the end of the 1920s and through the beginning of Great Depression. When the national park began in the mid- to late 1930s, all the resorts except Rock Harbor Lodge were closed, ending the golden era of genteel leisure on the island.

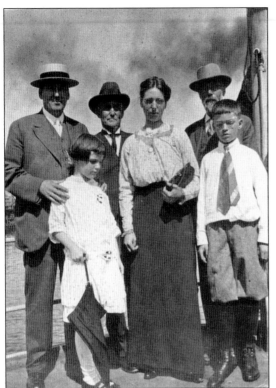

As the 19th century progressed, the numbers of people with leisure time and income to enjoy it increased. The Duluth-based Isle Royale Club camped at Siskiwit Bay and sponsored fishing trips, greenstone picking, and huge bonfires on the shoreline at night. Simply sitting and taking in the striking scenery of the island became an important part of this journey. Members of the Merritt family enjoy a nice day aboard the SS *America* en route to Isle Royale for a summer vacation. This snapshot, taken on the SS *America*, shows in the back row, from left to right, ? Merritt, a son of Nelson B. Merritt; Nelson B. Merritt; and Bessie A. Merritt and her father, Nelson G. Merritt, of Chautauqua County. Nelson B. Merritt took along a crate of oranges for the trip. (Isle Royale National Park Archive.)

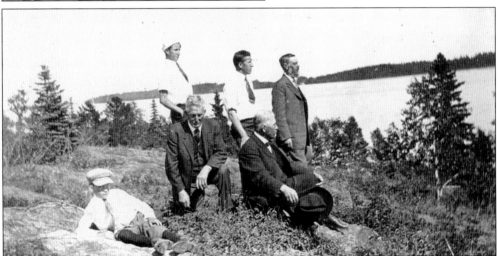

The earliest of the 19th-century leisure travelers to visit Isle Royale came by steamship from both the Canadian shore and the south shore of Lake Superior. Their steamships called primarily on the area around McCargoe Cove near the Minong Mine and the Island Mine site at the east end of Siskiwit Bay. During these short stops, excursionists fished, made a brief foray on shore, or simply took in the sights from the deck. The men of the Merritt family enjoy the Isle Royale scenery on a Sunday. Even on the island, these men, young and old, still sport their Sunday best. Pictured from left to right are (first row) Nelson H. Merritt (foreground), Nelson B. Merritt, Alfred Merritt; (second row) and Clark, Glen, and Nelson G. Merritt (Isle Royale National Park Archive.)

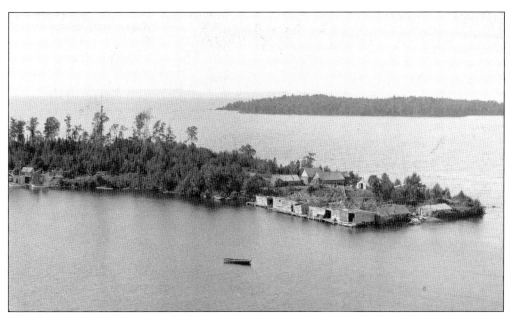

The local people also pursued the growing interest in recreation on the island as they supplemented money earned from fishing by guiding fishermen and hunters in the summers on their regular commercial fishing rounds. John F. and Catherine Johns, who owned the island, began taking in guests, which led, between 1887 and 1902, to the first hotel at Isle Royale. It was called either Johns Hotel or Barnum Island Hotel. (Isle Royale National Park Archive.)

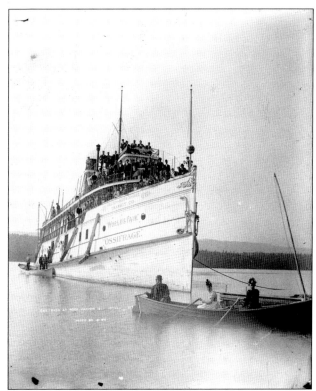

The 123-foot *Ossifrage*, a steamer that frequently called on Isle Royale, readies to disembark passengers at Rock Harbor for a brief visit to the island as part of its rounds to other ports at Port Arthur, Duluth, Superior, Houghton, and Marquette. The *Ossifrage* was built in Bay City in 1886, registered in Canada, and sailed the Great Lakes out of Detroit and Chicago. (Michigan Technological University Archives and Copper Country Historical Collections.)

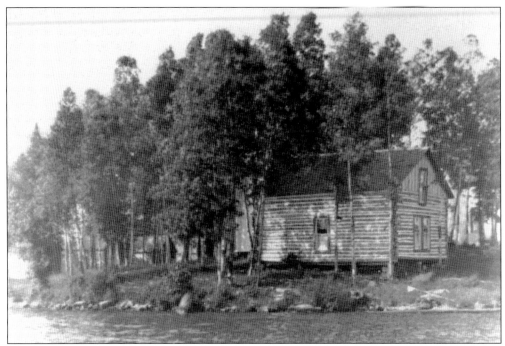

As the Victorian era progressed, many affluent individuals from around the Great Lakes sought to make a more permanent stay on the island. The Gust (Gus) Mattson family of Tobin Harbor opened the rustic Tobin Harbor Summer Resort. People raved about Mrs. Mattson's home cooking. Unfortunately the larger, more luxurious resorts at Rock Harbor and Washington Island were too much competition, and Gus returned to fishing. (Isle Royale National Park Archive.)

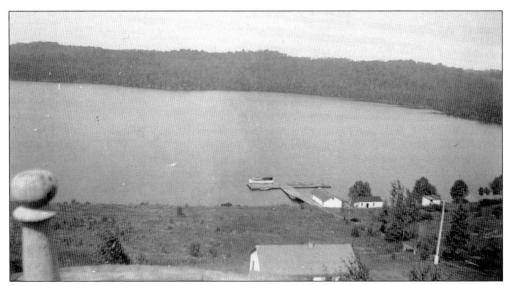

Led by Marshall H. Alworth and Col. C. H. Graves of Duluth, 20 Duluthians formed a private club called the Washington Harbor Club. They purchased surplus Wendigo Mining Company land and buildings at the head of Washington Harbor. At the club, the captains of industry enjoyed fishing and male bonding while being waited on by servants. Above is a view of the harbor from atop the water tower. (Isle Royale National Park Archive.)

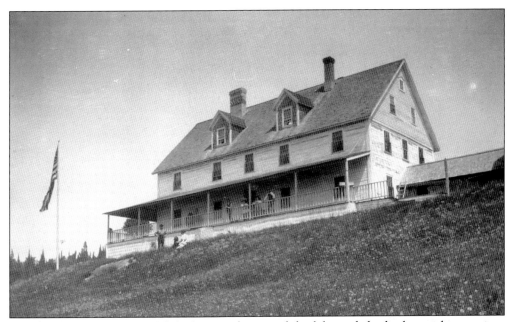

The Washington Harbor Club had a superb view of the lake and the harbor with a spacious veranda reminiscent of the one on the Grande Hotel at Mackinaw Island. This porch was added to what were once the offices of the Wendigo Mining Company. The clubhouse sported indoor plumbing and a sumptuous dining hall that offered food for the most discerning pallet. (Isle Royale National Park Archive.)

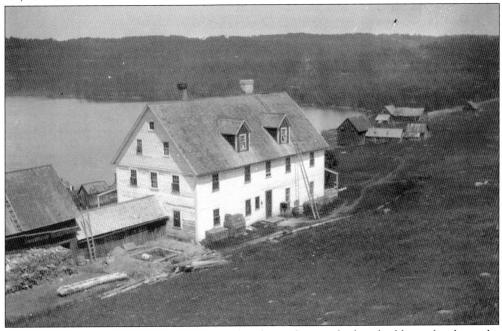

This shot of the rear of the clubhouse complex shows the attached outbuildings that housed a horse barn and space for winter storage of equipment used by the members. It also looks as if there is some kind of a cistern as well as a huge store of cordwood behind the larger attached structure on the left. (Isle Royale National Park Archive.)

Here some unidentified visitors at the Washington Harbor Club lounge outside the main clubhouse with a view toward the lake in the background. The photograph is dated 1908. (Isle Royale National Park Archive.)

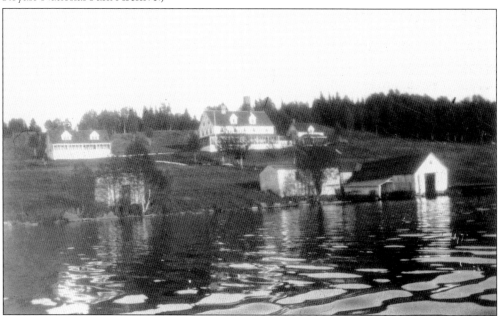

The wonderful main lodge (center, right) at the Washington Harbor Club was destroyed in a fire in 1933. This 1929 view from the harbor shows all the outbuildings in the complex, including the boathouse, perhaps designed to handle Col. C. H. Graves's 84-foot yacht *Picket*. The remaining buildings were taken over by the National Park Service as the Windigo Inn and operated until 1973. (Houghton County Historical Society Archives.)

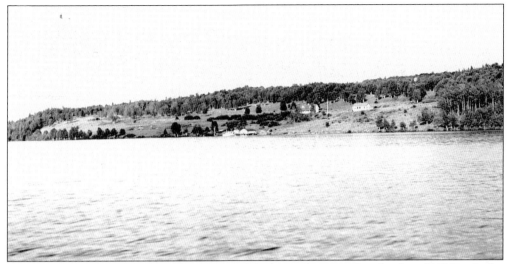

This 1939 view of the Washington Harbor Club shows the area after the fire of 1933 with the docks in the left center of the photograph. The ship at the dock is likely the converted yacht, the *Winyah*, which took over service on the island after the 1929 sinking of the SS *America*. Note that the boathouse and the main lodge are gone. (Isle Royale National Park Archive.)

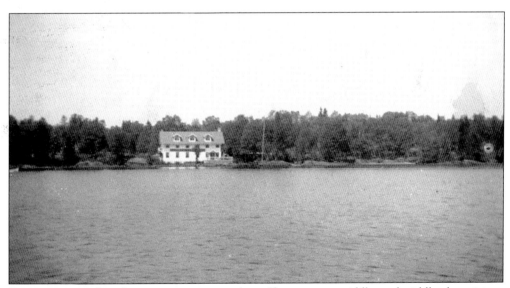

For every upper-class elite visitor, many more less-affluent, upper-middle- and middle-class visitors found Isle Royale a paradise. Between 1902 and 1904, Kneut Kneutson and partner John E. Tappen bought a mile of shoreline and opened the Park Place Resort at Snug Harbor. It was to become what is shown in this 1937 photograph as Rock Harbor Lodge. The Spruces Cabin from this resort remains on the Rock Harbor waterfront. (Isle Royale National Park Archive.)

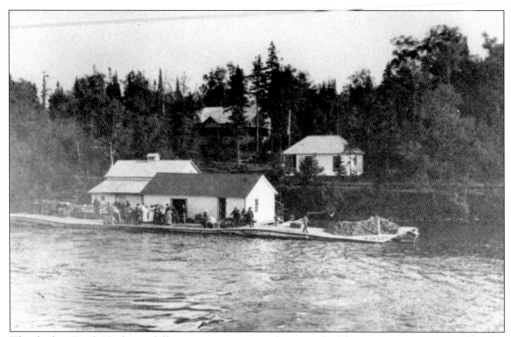

The dock at Rock Harbor is full as passengers await the arrival of the SS *America*, operated by the A. Booth Transportation Company, around 1904. The docks were located to the west (left) of the lodge shown in the previous picture. The water at the shore is very deep, which is an advantage for docking the large ships parallel to the shore. (Isle Royale National Park Archive.)

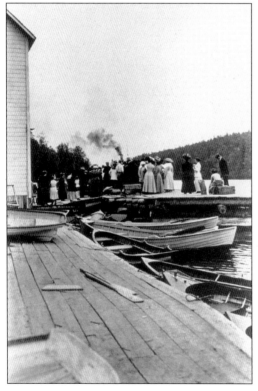

Here passengers await the SS *America* as it comes into port at Rock Harbor. The echo of its whistle off the hard rock shores must have been spectacular, combined with the muffled puffing of the steam engines as it came alongside of the dock. (Isle Royale National Park Archive.)

As a result of the increased demand for luxurious accommodation for summer resorters, the A. Booth Transportation Company and an upstart competitor, Capt. William H. Singer of the Lake Michigan and Lake Superior Transportation Company, got into the resort business. While Booth worked closely with several other resort operators, Singer built the Island House Resort and what was called Singerville, beginning in 1902. The goal was to operate the most luxurious resort to date on Isle Royale. (Isle Royale National Park Archive.)

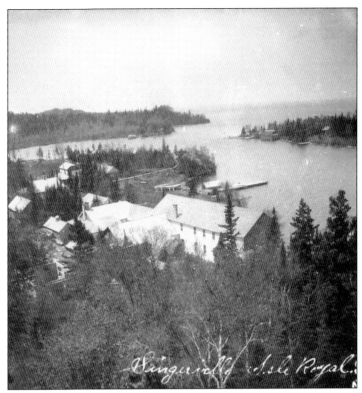

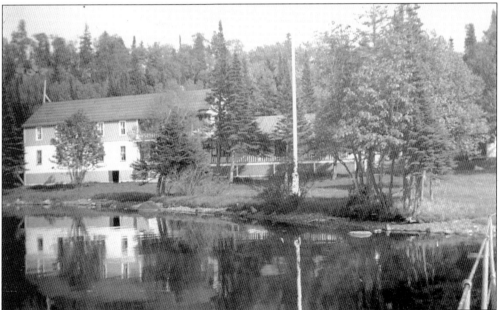

When Capt. William H. Singer built the resort and Singerville, he spared no expense. The main lodge was almost 150 feet long with 22 bedrooms, a barbershop, a poolroom, a spacious rustic lobby, and huge porches that gave great views of the harbor as well as the Minnesota and Ontario shores. A 1937 National Park Service photograph shows the lodge building with its distinctive two-toned siding. (Isle Royale National Park Archive.)

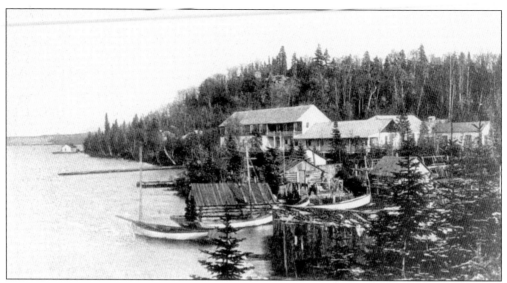

The Island House Resort dock was always a busy place, and the pre-1910 photograph above shows the dock complex with the boats and fish houses in the foreground. The dock is quay style, extending out into the lake at a right angle to the shore. In 1910, Capt. William H. Singer was the first on the island to use a wireless radio, installing a tower on Sunset Rock to communicate with his vessels about weather and lake seas and to make reservations at the resort. (Isle Royale National Park Archive.)

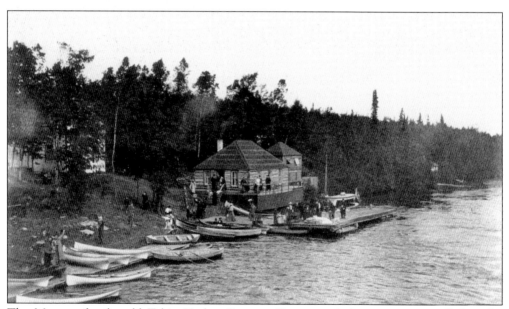

The Mattson family sold Tobin Harbor Summer Resort, and the new owner called it the Minong Island Resort. The new owners kept the rustic feel but upgraded the cabins, lodge, and especially the dock facilities to handle ships like the SS *America* and Singer's boat *Bon Ami*. Note the rowboats clustered about the docks for use by patrons for fishing. (Isle Royale National Park Archive.)

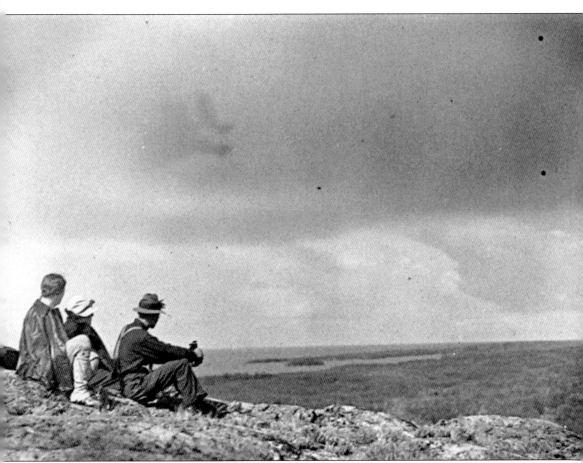

On a clearer day, one could have seen the Canadian shore, but, from left to right, Lucy Dassler, Mrs. Connolly, and Rev. Charles Parker Connolly enjoy the view just the same as they look out over the north end of Isle Royale from atop Mount Franklin. (Isle Royale National Park Archive.)

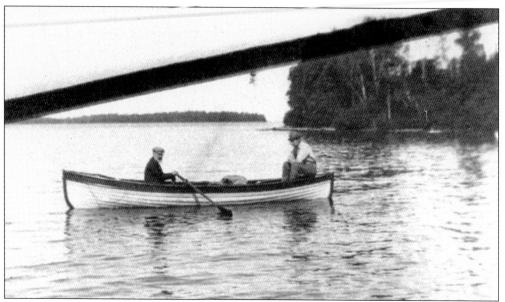

In parallel with the growth of resorts, many cottages sprung up around the resorts, especially around Tobin Harbor. Cottagers used steamboat transportation to come to the island in the summer and then spent the summer fishing and enjoying the retreat from city life. Such was the situation for Judge Charles F. W. Dassler and his family from Leavenworth, Kansas. Here he is seen boating (left, front) with his son Carl at Tobin Harbor in 1913. (Isle Royale National Park Archive.)

The Dassler family built its cottage, a typical frame structure with board and batten siding and simple tilt-out windows, near Tobin Harbor. This is a view of the cabin in 1909. Since ships brought supplies to the resort, Lucy Dassler put in her order at the lodge and it arrived on one of the weekly boats. (Isle Royale National Park Archive.)

This photograph shows Lucy and Dale Dassler inside the cabin sitting down to a meal of major proportions with their family. Fortunately families of the early 20th century had embraced George Eastman's Kodak camera invention wholeheartedly. It allows one to see a wonderful, candid slice of life that the photographic technology of the previous century could not provide. (Isle Royale National Park Archive.)

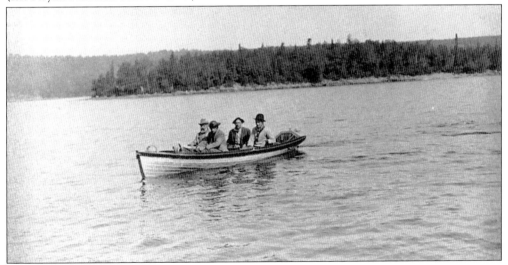

After a pleasant midday meal, it was not unusual for members of the family to take to the water for a jaunt on the harbor. Here it looks like Carl Dassler is at the helm of the *Carl*, the family's fishing boat. It appears to be powered by an early outboard engine. In the 19th century, either oars or, if one was wealthy, a small steam launch were the only choices. (Isle Royale National Park Archive.)

In 1908, Judge Charles F. W. Dassler, his sons Carl and Dale, Wilder Lawrence, and Rev. Charles Parker Connolly took a weeklong cruise around the entire circumference of Isle Royale. The wonderful story of this trip by Connolly can be found in *Borealis: An Isle Royale Potpourri*. Pictures from this epic fishing journey are found in the next chapter. Here a motor launch similar to theirs sets off with a flag flying on an adventure in 1912. (Isle Royale National Park Archive.)

The cottages built by families on Isle Royale were the sources of many memories for several generations. On a fishing trip in 1927, Dassler stands with the now mature Dale, H. O. King, and Connolly in 1927. (Isle Royale National Park Archive.)

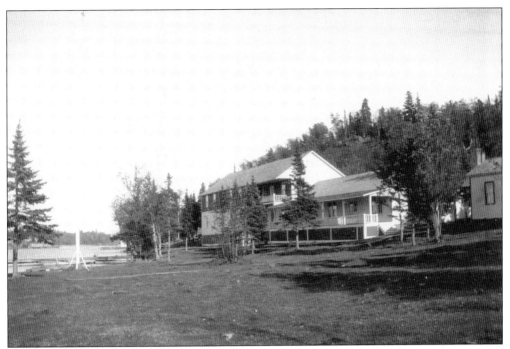

The Island House Resort offered accommodation in both the main lodge, shown here, and also in cabins that were rented or purchased by families. The cabins were ideal for families with young children because they provided more flexibility. (Isle Royale National Park Archive.)

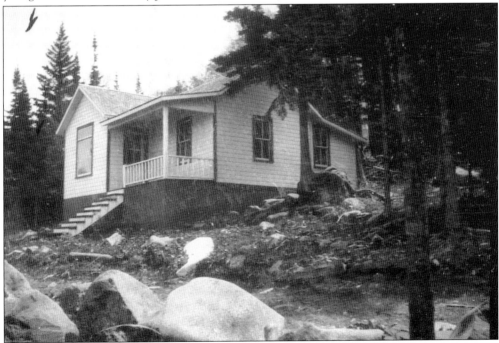

Here is a trim cabin from the Island House complex in 1902. Each cabin is shiny, new, two-tone white with a dark color trim and plenty of room for a family. The picture is dated 1902. (Isle Royale National Park Archive.)

An unidentified family group "hams it up" for the camera outside the front stoop of its Island House Resort cabin. The exposure appears to be from the late-afternoon sun, which is filtering in through the trees, highlighting the massive rocks in the front yard. This photograph is dated 1902, apparently on the opening year of the resort. (Isle Royale National Park Archive.)

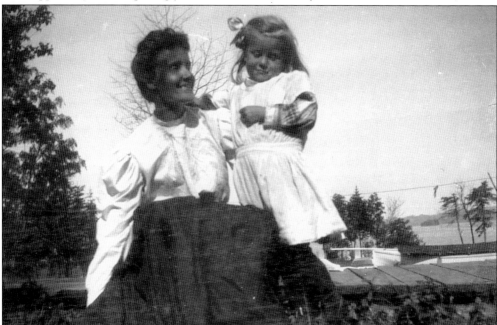

The handwritten note on this picture sums up the feelings and memories of these golden times on Isle Royale. An unidentified mother and daughter at the Island House Resort in 1902 enjoy their time in the sun. The note on the edge of the photograph simply reads, "Sweethearts." (Isle Royale National Park Archive.)

# Six

# THE FISHERMEN

Isle Royale's rocky coastal bays and deep, clear, cold Lake Superior waters have harbored fish of incredible size and variety before and since the last glaciers receded around 50,000 years ago. Lake trout, brook trout, freshwater herring, whitefish and its smaller cousin the menominee, chubs, smelt, and burbot or ling (a freshwater cod) are the fishes that have been caught by fishermen from Native American times until today. In the inland lakes and streams on the island, northern pike and brook trout, many of dramatic size, have provided both food and sport for fishermen through the ages.

It was the commercial value of this vast fishery that brought white fishermen with the Northwest Fur Company to set up remote fishing stations on Belle Isle and in remote coves and bays as early as 1800. These fishermen, and eventually their families, put down roots with sturdy wooden boats, fish docks, boathouses, net-winding rigs, and rough-and-tumble housing, providing the base of operations for these hardy souls. In the early years, their catch was commonly wood-smoked, salted, or iced with ice cut from inland lakes, as refrigeration was not yet available. A strong commercial fishery was maintained until the decline of whitefish in the 1890s and the entry of the first and most devastating of several introduced species, including the sea lamprey, which traveled up the St. Lawrence River from the Atlantic Ocean and into the Great Lakes in the 1950s. Combined with the pressure of overfishing, the coming of the sea lamprey, and the initial introduction of Pacific salmon, the end of all but sport fishing in the waters around Isle Royale until the end of the 20th century was sounded. In recent years, native fish have returned to near 19th-century levels through careful management of the lamprey and salmon populations. Tighter regulation of catches allows sport fishermen and a few commercial fishermen, mostly Native Americans from tribes of the region, to bring home fish from these waters. The National Park Service also operates the Edisen fishery as a cultural demonstration.

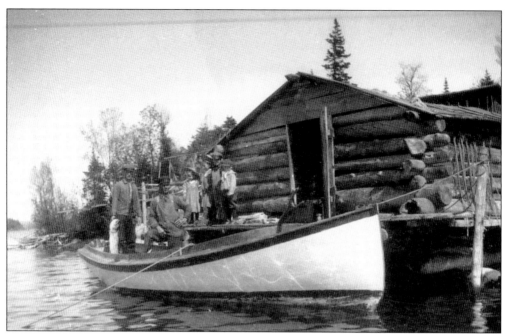

A local fisherman displays a lake trout in the 20-pound class from his fishing boat at his log-hewn fish house dock. While big trout were much more common in the early years, by the start of the 19th century a truly big trout like this was still noteworthy enough to warrant a photograph. Note the children lined up to get in the picture. (Isle Royale National Park Archive.)

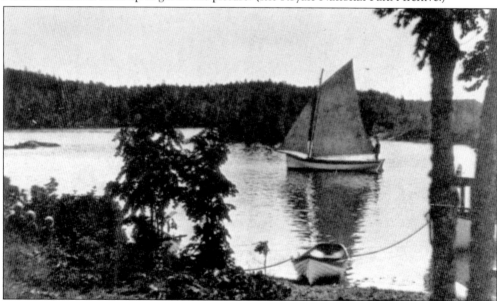

A simple gaff rig with a jib ahead of the mast was the primary design of fishing boats during the 19th century. If the weather did not favor sailing out to the fishing grounds, these boats could also be rowed handily. As the years progressed and the fishing business moved from seasonal to year-round, gas engine–powered, fully covered fish tugs replaced these graceful boats. This view from Johnson's fishery at Rock Harbor was captured in 1908. (Isle Royale National Park Archive.)

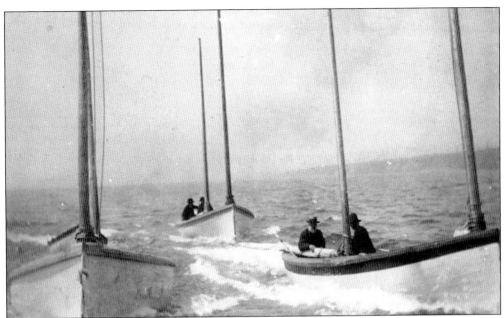

In the years around the dawn of the 20th century, as netting technology allowed larger nets to be deployed, fishermen often towed multiple boats out to the net sites, as shown in this picture. The boats in this photograph are also larger and sport a main mast and a staysail mast. They are being towed by a larger boat, most likely a gas-powered launch. (Isle Royale National Park Archive.)

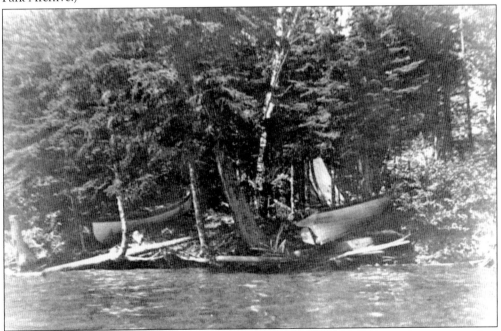

Dockage was always at a premium as it required heavy work to construct and winter ice often destroyed them. Therefore, successful fishermen often tied up their principal launch and newest boats to their docks and shore-hauled the rest of their fleet along the tree-lined shore. These are boats at Huggins Cove in 1908. (Isle Royale National Park Archive.)

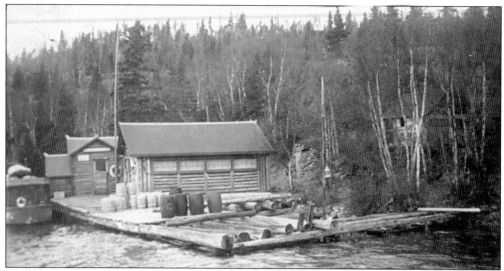

Fishermen's docks were also constructed in areas where the shoreline was quite steep, and this created the need to be creative, as evidenced by this picture. The dock construction is what is still called crib construction, where a crib of rough-hewn logs is filled with rocks and boulders, and then decked with rough-cut planks to form a dock. This plan of dock construction was used here at Holger Johnson's store in the 1930s. (Isle Royale National Park Archive.)

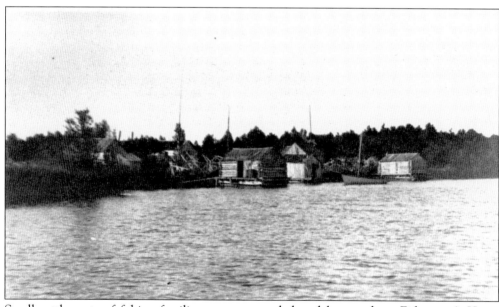

Small settlements of fishing families grew up on sheltered bays such as Fisherman's Home (pictured here in 1913), Siskiwit Bay, Chippewa Harbor, and at the earliest on Belle Isle, which was built by the American Fur Company in 1837. The Belle Isle site sported a salt house, a cooper's shop, a storehouse, and a barracks for the single men. Family men had to build their own camps, and many stayed after the fur company collapsed in the depression of 1837 to 1841. (Isle Royale National Park Archive.)

For centuries, fishermen used cotton nets. In order to prevent them from rotting, they needed drying racks, such as those pictured, to dry and to organize them between trips to the fishing grounds. This image from around the dawn of the 19th century shows net winders lining the shore near the Mattson and Anderson Fisheries in Tobin Harbor. The Musselman cabin can be seen on one of the small islands in the distance. (Isle Royale National Park Archive.)

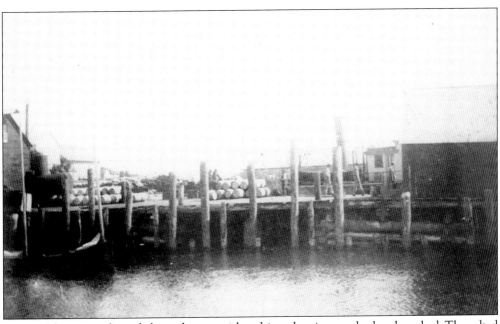

Once a fish was caught and cleaned, it was either shipped on ice or salted and smoked. The salted and smoked fish was packed in barrels for shipping to mainland ports such as Fort Arthur (now Thunder Bay, Ontario, Canada), Duluth, Superior, and Ashland, and to the major population centers of the nation. Here barrels ready for shipping await the arrival of a steamer around 1890. (Isle Royale National Park Archive.)

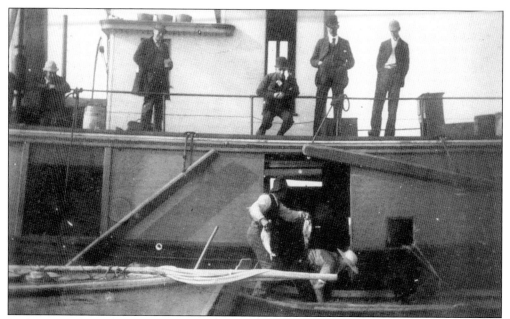

In this 1908 photograph, fresh fish are being loaded directly into the fast packet streamer *T. H. Camp* for shipment on ice to markets and railroad transshipment to ports such as Duluth, Minnesota, and Superior or Ashland, Wisconsin. Here the fish were repacked and loaded again on ice in ice bunk refrigerator cars for delivery to Milwaukee, Minneapolis, and Chicago. The fresh fish being loaded would do any sporting fisherman proud. (Isle Royale National Park Archive.)

In the early 1900s, gas- or diesel-powered fish tugs followed the graceful sailboats and steam launches used by fishermen of the 19th century. They sported a long covered foredeck to allow for winter fishing in the open lake. The large side door allowed for the handling of nets with a minimum of exposure to lake waters that rarely exceed 40 degrees most of the year. (Houghton County Historical Society Archives.)

At the beginning of the 20th century, the growth and affluence of the cities of the Midwest brought about a growth in outdoor sports, tourism, and camping on Isle Royale. In this 1908 photograph, Judge Charles F. W. Dassler's motor launch, the *Mystic*, and a fine, old wooden rowboat (possibly the *Carl*) prepare for a day of sport fishing on the island's waters. Seated on the foredeck is the judge's grandson Dale Dassler. (Isle Royale National Park Archive.)

The *Mystic* motor launch towing the rowboat *Carl* is heading out to troll the rock reefs with heavy reels fit with wire line and a lure system called cowbells. Cowbells was a series of flashing chrome-tin spoons and treble hooks baited with smelt or strip sucker meat. While the motorboat trolled, the rowboat occupants likely anchored to fish using spoons or live bait. This photograph was taken in Tobin Harbor in 1912. (Isle Royale National Park Archive.)

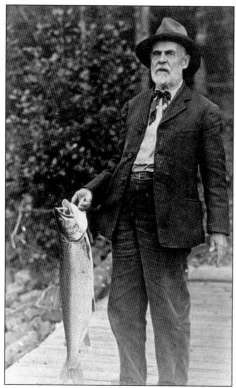

Those trolling in the deep waters of the lake quite often caught the hog-sized lake trout like the one pictured on the left. Many a sportsman from Chicago, Kansas City, and other midwestern cities posed for a trophy photograph with their *siskwit* (large lake trout) prize and then settled down for a superb shoreside dinner. Pictured is Judge Charles F. W. Dassler in 1908 with a 13-pound catch. (Isle Royale National Park Archive.)

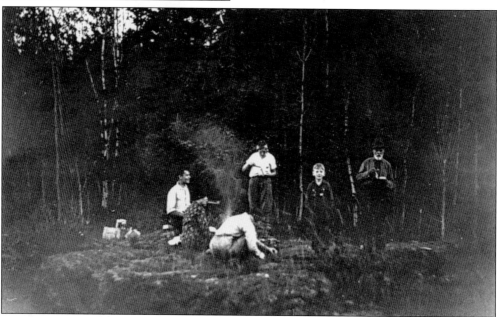

After a successful day of fishing, the party returned to its shoreline camp for a meal of fresh lake trout fried in a cast-iron skillet while swapping stories until all retired. In the early morning, the ritual was repeated. Here Rev. Charles Parker Connolly (extreme right) and Mrs. Connolly (center, in print dress) enjoy a shoreline meal with the family in the 1920s. (Isle Royale National Park Archive.)

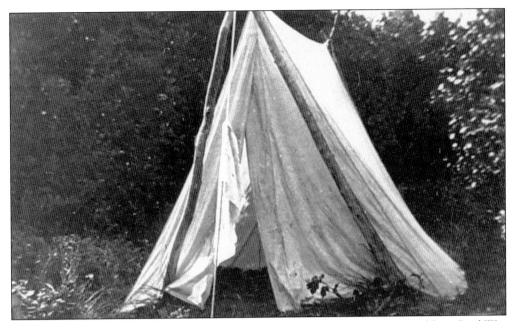

Tent camping in the 19th century and early years of the 20th century was more like a Civil War bivouac than something one might do for pleasure. Tents were made of muslin canvas without floors and often required the user to harvest poles from the surrounding forest. The floor was made of pine or spruce boughs piled up to provide a soft bed. Dreams of an even bigger fish tomorrow often followed. (Isle Royale National Park Archive.)

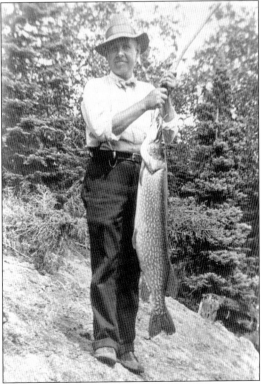

Fishing in the inland lakes and streams of the island also offered great sport in the form of both muskellunge and northern pike. The 12- to 15-pound muskellunge, or "muskie," held up by Carl Dassler was from Chippewa Lake. Both species of fish are solitary, stealthy hunters that commonly feed not only on other fish but also on muskrats, ducklings, and large bullfrogs. Both the muskie and northern pike seem to simply bite a lure out of sheer meanness. (Isle Royale National Park Archive.)

In the early years of sport fishing on Isle Royale, northern pike and muskellunge fishing yielded monsters like the one displayed here by the Rev. Charles Parker Connolly in 1918. Some of these fish weighed in at 20 to 30 pounds and broke all but the strongest tackle. (Isle Royale National Park Archive.)

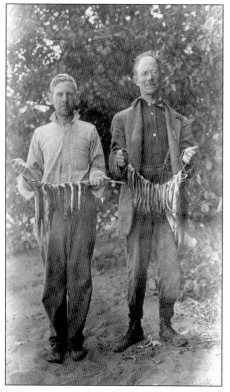

A truly beautiful member of the trout family, the brook trout, or "brookie" as they are known, has colorful spots on its skin and a luscious pink meat that is sought after by epicures the world over. The two sporting gentlemen in this 1908 view are holding up their catch from one of the numerous brook trout streams that flow to Lake Superior or inland lakes that dot the island. John Carl Dassler is pictured on the left. (Isle Royale National Park Archive.)

Today trout fishermen can only dream of brook trout catches like these two beauties. In the days when this photograph was taken, there were no limits on the size of catch or any thought of catch and release sport fishing. The Isle Royale of days gone by was truly a sport fishing paradise. (Michigan Technological University Archives and Copper Country Historical Collections.)

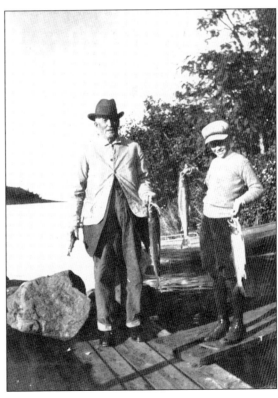

The various Merritt families for whom Merritt Island, Merritt Lane, and the Merritt Lane Campground are named were avid sport fishing families and left a wonderful photographic record of their years on Isle Royale. From their camp, known as Camp Comfort, they trolled the waters around Blake Point and Rock Harbor. Nelson M. Merritt and grandson Nelson H. Merritt display the first catch for the camera. (Isle Royale National Park Archive.)

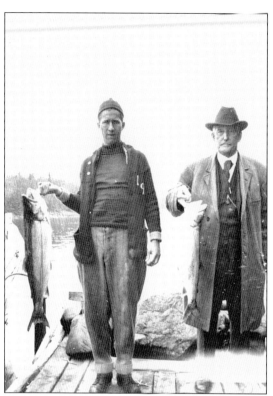

Nelson B. Merritt and Glen Merritt happily show off a 15-pound lake trout and a slightly smaller one they caught trolling. Fish of this size are still caught around the island today. (Isle Royale National Park Archive.)

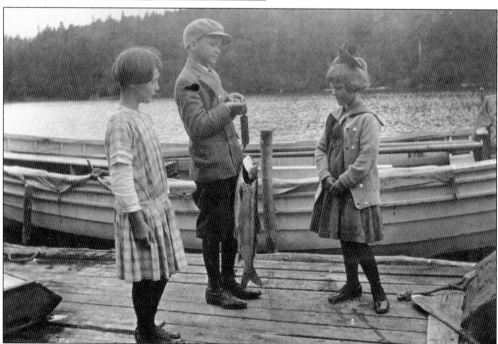

Even the kids get in on the action at Camp Comfort. It looks like Nelson H. Merritt (center) will win the fishing prize with this seven-pound lake trout. Barbara (left) and Jean Merritt look on approvingly. What a great time to be a kid on Isle Royale. (Isle Royale National Park Archive.)

# Seven

# Ships and Shipwrecks

When popular singer Gordon Lightfoot's 1976 song "The Wreck of the Edmund Fitzgerald" climbed the pop charts commemorating the loss of 29 crewmen in November 1975, the drama and tragedy of Great Lakes shipwrecks finally gained wide public attention. While this type of tragic incident is far from uncommon on Lake Superior, it riveted the public eye on the true dangers of travel on the greatest of the freshwater inland seas: Lake Superior.

The area around Isle Royale and the Keweenaw Peninsula have historically been areas where ships are "bones to be chewed" by Lake Superior's moods, as well as obstacles that heighten the potential for wrecks due to human error.

Beginning with the first Americans through modern times, Isle Royale has presented a special hazard because of its shallow, rocky shoals and its location in the path of the Alberta Clipper storms that the Canadian Shield sends from the northwest. While the most severe weather develops farther east after the winds reach across the widest expanse of Lake Superior, in the area around Whitefish Bay, the narrowing of the lake between the Keweenaw Peninsula and Isle Royale and Isle Royale's rocky coast have also spelled doom for hapless ships.

Despite Lake Superior's moods, the passage to Isle Royale has held special joy for many, from cottagers and resort folk to wives and children rejoining husbands toiling in the mines and forests. For every wreck there are thousands of sailings that are uneventful and many times awe-inspiring in ways only the majestic coastline, a Lake Superior sunset, or sunlit cloudscape could provide. Approaching the island past the Palisades, passing Rock of Ages bound for Washington Harbor, or carefully sailing through Middle Islands Passage en route to Rock Harbor are all experiences shared by ships' passengers and sport mariners alike.

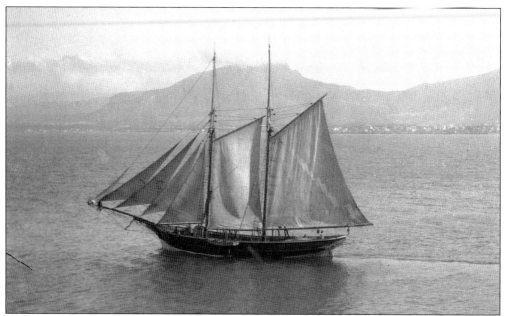

During the War of 1812, the British captain Robert McCargo hid his ship, the schooner *Recovery*, in McCargoe Cove to prevent its capture by the Americans. While there was no trading port on Isle Royale until the American Fur Company opened one at Card Point after the war, lake travelers used the rock bays as ports of refuge for centuries. The schooner *Columbia*, under full sail, is typical of the breed. (Superior Views.)

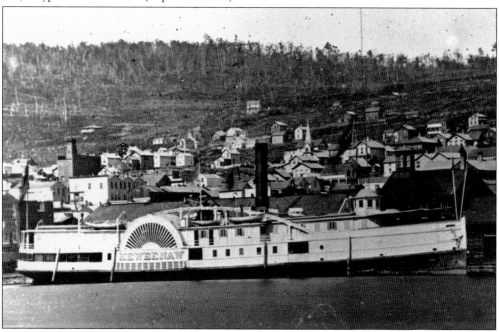

Once the mining boom began in the region, Isle Royale was visited by a variety of sail and steamships from both Canada and the United States. One of the earliest of these, built in 1866, was the *Keweenaw*, which brought people, machinery, and supplies to the island. (Jim Dan Hill Library, University of Wisconsin–Superior.)

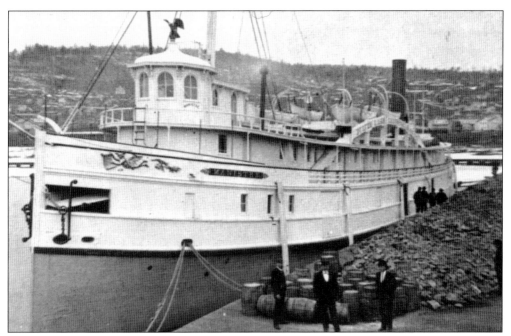

The *Manistee*, which went on excursions in the post–Civil War era, was 155 feet long, and, unlike the *Keweenaw*, was a propeller-driven ship. Built in 1867 in Cleveland by Peck and Masters, it foundered with the loss of 23 lives off Ontonagon in November 1883. (Jim Dan Hill Library, University of Wisconsin–Superior.)

The 200-foot-long steamer *Pewabic* was also built by Peck and Masters in Cleveland but had a short life in the lakes excursion business. On August 9, 1865, the ship was sunk off Thunder Bay in Lake Huron in a collision with the propeller-driven *Meteor*. Fifty lives were lost. (Jim Dan Hill Library, University of Wisconsin–Superior.)

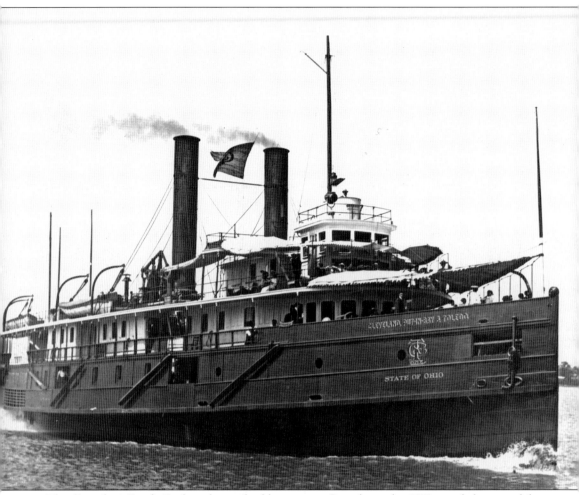

The Canadian Pacific Railway began building across Canada in the 1870s, and the cross-lake ship traffic on Lake Superior took a jump. This massive project, coupled with the second mining spurt on Isle Royale, meant ships stopped frequently. The 225-foot propeller ship *City of Cleveland* made regular runs to the Minong and Island Mines wharves. While in port, excursion passengers were boated over to Rock Harbor for the afternoon to pick greenstones. (Jim Dan Hill Library, University of Wisconsin–Superior.)

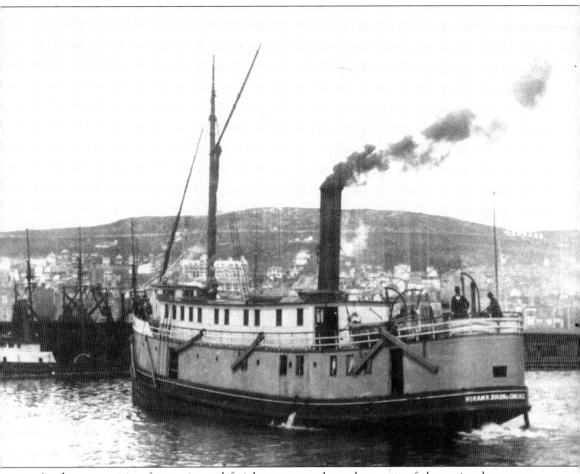

As the competition for tourist and freight transport heated up, one of the main players was A. Booth and Company with ships like the *Hiram R. Dixon*, a wooden-hull, 118-foot propeller ship. It was a fast and quite luxurious boat, according to contemporary reports. Along with its sister ship, the *Camp*, it made frequent and speedy calls on the island. (Jim Dan Hill Library, University of Wisconsin–Superior.)

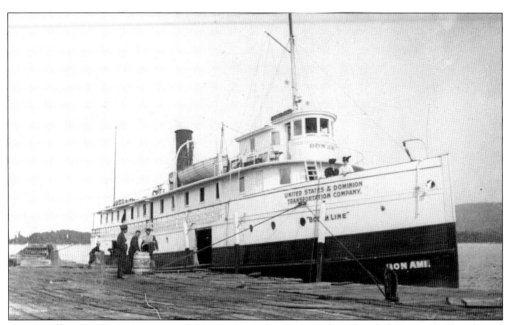

Capt. William H. Singer, a successful captain on the Great Lakes, decided to give A. Booth and Company a run for its money in the Lake Superior shipping game in the early 20th century, kicking the resort trade into gear on Isle Royale. Singer built his luxury Island House Resort and served it with his fleet of ships, including the 108-foot, wood-hulled steamer *Bon Ami*. (Jim Dan Hill Library, University of Wisconsin–Superior.)

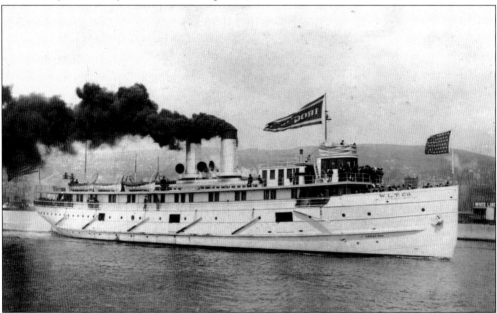

As the trade grew, Singer lavishly expanded the resort. In 1902, he purchased a newer, sleeker steel-hulled ship, the 214-foot propeller *Iroquois*, which was built in 1901 in Toledo. The expansion of Singer's business went apace too fast, and a string of misfortunes, including a fire on the *Bon Ami* and constant accidents with the *Iroquois*, put him out of the business in 1904. He drowned a few years later. (Jim Dan Hill Library, University of Wisconsin–Superior.)

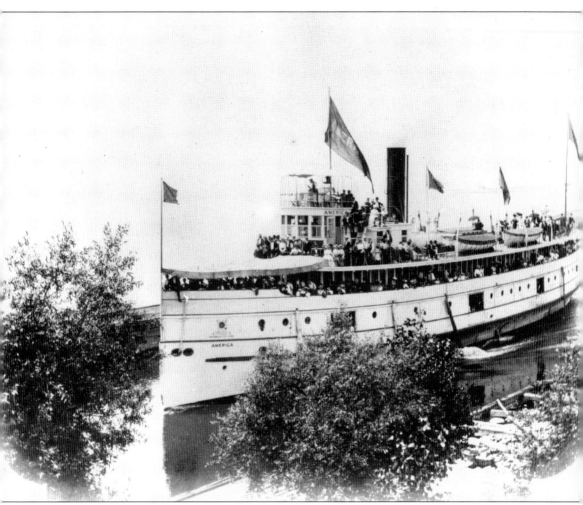

A. Booth and Company also had a workhorse that operated up until June 7, 1928, when it struck a reef and sunk off Washington Harbor. The SS *America* was a 165-foot-long, steel-hulled ship built in Wyandotte at the Detroit Dry Dock in 1898. The SS *America* was a familiar friend to islanders for 30 years, bringing mail and supplies to Isle Royale almost year-round. It was rebuilt and lengthened to 183 feet in 1911. (Jim Dan Hill Library, University of Wisconsin–Superior.)

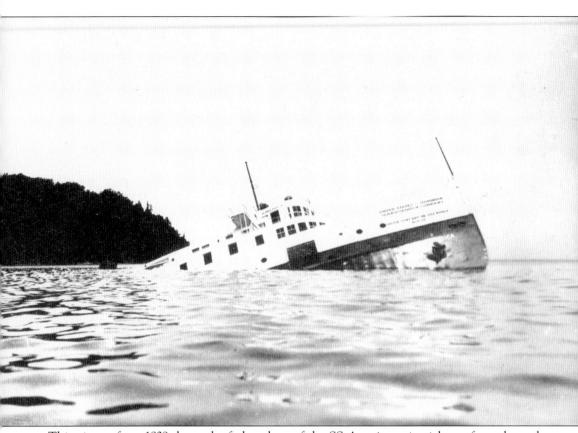

This picture from 1929 shows the forlorn bow of the SS *America* as it sticks up from the rock reef that it hit. Fortunately due to the time of year and the close proximity to the shoreline, no lives were lost. There were brief discussions in the 1950s about refloating the ship, but it did not happen because of the extreme cost. (Michigan Technological University Archives and Copper Country Historical Collections.)

The waves crashing over Blake Pointe Reef are beautiful but can prove dangerous to passing ships. Reefs such as these occur all around the island, causing many shipwrecks. (Isle Royale National Park Archive.)

As one looks toward Isle Royale from Passage Island, one can see just how critical the Passage Island Lighthouse was to those early ships. Isle Royale does not rise straight out of the sea; the smaller islands and rocks seem to reach out in nearly every direction hoping to snag the hull of a passing ship. (Isle Royale National Park Archive.)

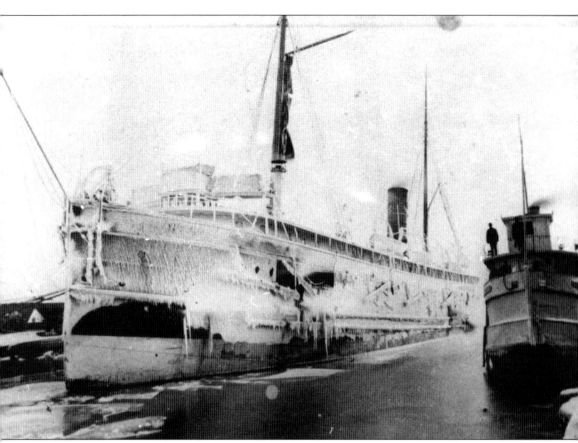

The steel-hulled passenger ship fleet operated by the Canadian Pacific Railway around the beginning of the 19th century was the epitome of Victorian seagoing elegance. The *Algoma* was built in 1883 in Glasgow, Scotland. On November 7, 1885, its short, elegant life came to an end when it was driven into the rocks on the south side of Mott Island in a gale and ice storm, breaking up overnight and taking 45 lives with it. (Jim Dan Hill Library, University of Wisconsin–Superior.)

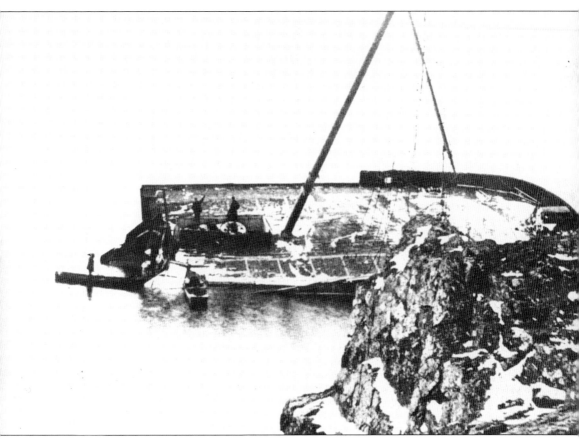

Here a couple of men walk the remains of the *Algoma* after the tragic sinking. The date on the photograph is not clear, but it captures the rocks that took it down and what remained after the lake and salvagers were done with it. (Jim Dan Hill Library, University of Wisconsin–Superior.)

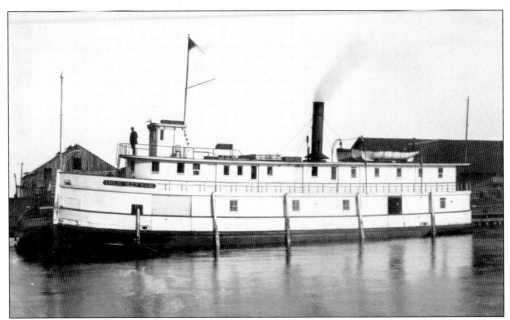

The passenger steamer *Isle Royale* was built in 1879 at Maine City as the barge *Agnes*. It was renamed the *Isle Royale* in April 14, 1884, in Duluth. On July 25, 1885, it sprung a leak and sank eight miles west of Washington Harbor en route from Port Arthur to Duluth. This elegant little steamer made many trips to Isle Royale. Note the moose horns on the pilothouse. (Michigan Technological University Archives and Copper Country Historical Collections.)

Canoe Rocks, just past the Passage Island Light heading westbound and three and a half miles off Blake Point, has been a frequent nemesis of ships heading to and from Thunder Bay on the northeast end of the island. The *Chester A. Congdon*, (formerly the *Salt Lake*), a 532-foot bulk carrier heading southbound on November 8, 1918, with a load of grain from Fort William (Thunder Bay), Ontario, struck the southerly reef and broke in half, as this view shows. The crew escaped, but the ship was a total loss. (Jim Dan Hill Library, University of Wisconsin–Superior.)

The reason they are called Canoe Rocks is because they look like moving canoes when there is wave action around them. In a storm, they virtually disappear. On June 4, 1947, twelve sailors lost their lives when the 525-foot Canadian bulk carrier *Emperor* struck the rocks and broke in two. The ship was loaded with iron ore heading from Port Arthur to Ashtabula, Ohio. (Houghton County Historical Society Archives.)

The Bransford Reef, just nine-tenths of a mile east of Point Houghton on the southwestern side of Isle Royale, is part of a chain of rock reefs that point straight at Menagerie Island. The reef is named for the 414-foot bulk carrier *Bransford*, which went aground on these rocks in a storm on November 16, 1909. It was successfully pulled off and served a long life until 1974 when it was scrapped in Spain. (Houghton County Historical Society Archives.)

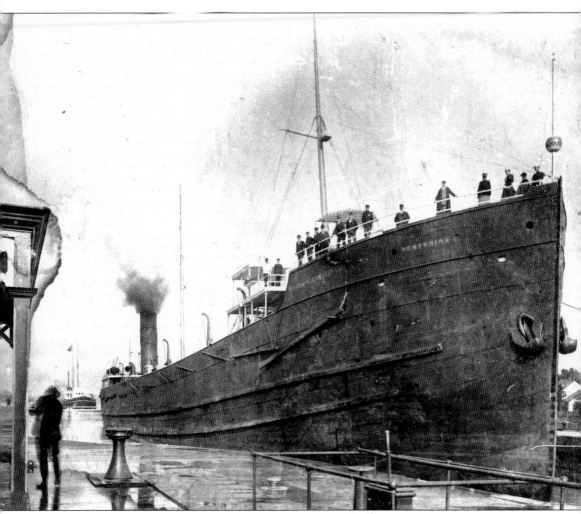

San Antonio Reef, only 3.1 miles east of Point Houghton, was the site of the stranding of the steamer *Centurion* in 1895. The reef was named after Norwegian fishermen's corruption of the word *centurion*. The *Centurion* is passing through the Soo Locks in this postcard view. (Jim Dan Hill Library, University of Wisconsin–Superior.)

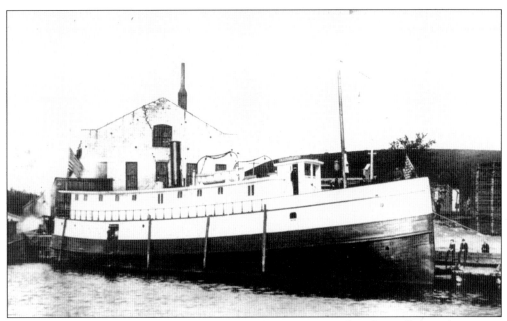

The steam-propelled *A. B. Taylor* was a 106-foot-long passenger ship that called on the various mine ports on Isle Royale until it ran aground in 1890 on the same rock reefs that caught the *Bransford* in later years, only four miles closer to Point Houghton. The rock formation is now known as Taylor Reef. The *A. B. Taylor* burned to the waterline at a dock in New York in 1910. (Jim Dan Hill Library, University of Wisconsin–Superior.)

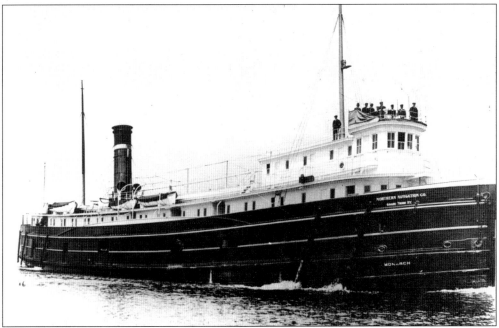

The stately *Monarch* in 1904, before its sinking on the Palisades at Isle Royale, is a symbol of the glory days of steam travel to this wonderful island. The crew is arrayed atop the pilothouse as the ship marches outbound and into the list of lost ships of Lake Superior. (Jim Dan Hill Library, University of Wisconsin–Superior.)

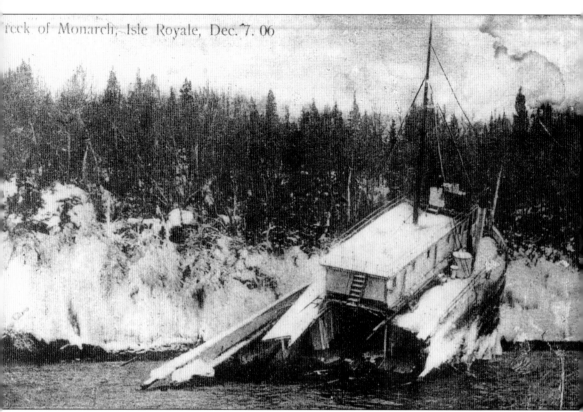

One of the most terrible wrecks in the history of Isle Royale was the December 10, 1906, wreck of the 240-foot-long *Monarch*. Owned by the Northwest Transportation Company of Sarnia, Ontario, the Canadian beauty was bound for Port Arthur when it rammed the Palisades four-tenths of a mile south of Blake Point. In spite of temperatures 20 degrees below zero, only one man died by falling into the icy waters. (Jim Dan Hill Library, University of Wisconsin–Superior.)

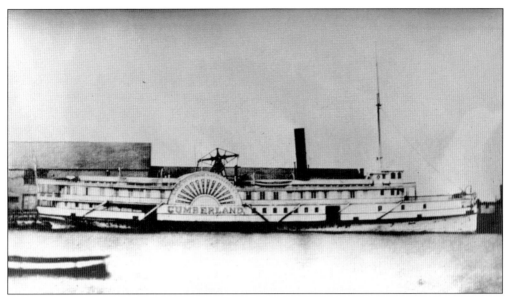

The earliest recorded wreck off Isle Royale was that of the paddle-wheel steamer *Cumberland* of Canadian registry. Built in 1871 in Port Robinson, Ontario, it was over 200 feet long and a queen of the lakes at only six years old. It was heading from Port Arthur to Duluth when it ran aground on the Rock of Ages due to a navigation error caused by a faulty chart. No lives were lost. (Jim Dan Hill Library, University of Wisconsin–Superior.)

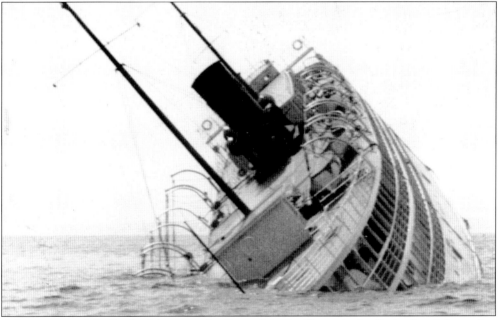

Other victims of the Rock of Ages are the *George M. Cox* (formerly the *Puritan*) and the packet steamer *Henry Chisholm* that sank in 1898 almost on top of the *Cumberland*. The 259-foot-long *George M. Cox* was on its maiden voyage after its renaming when it went aground on the Rock of Ages reef. The ship was a total loss, but all passengers, including George M. Cox, made it to the lighthouse safely. (Michigan Technological University Archives and Copper Country Historical Collections.)

The *George M. Cox* started its life as the *Puritan* and was built in Toledo in 1901. The *Puritan* did a stint with the U.S. Navy during World War I, from 1918 to 1919, as a troop transport. In the years after the war it went through four owners before it was bought by George M. Cox for his Isle Royale Transportation Company in 1933. (Jim Dan Hill Library, University of Wisconsin–Superior.)

The *Glenlyon*, pictured here in Duluth as the *William H. Gratwick*, was built in 1893 and was a 328-foot-long steam-powered bulk carrier. It was lost on Menagerie Island on November 1, 1924, when the ship was stranded by a severe gale, a November Witch of sailors stories. The ship, carrying 143,000 bushels of wheat from the Great Plains, broke in half and was a total loss, but no lives were lost. (Jim Dan Hill Library, University of Wisconsin–Superior.)

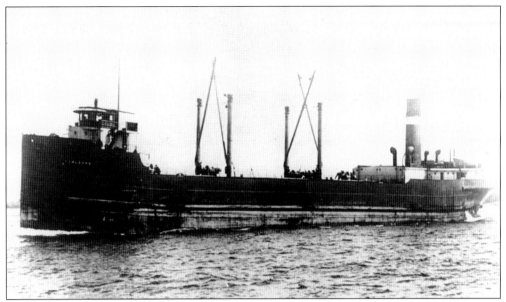

On December 7, 1927, the 250-foot Canadian freighter *Kamloops* was making its way into a blinding snowstorm with a full load of wire in the holds when it sunk. The ship was not rediscovered until 1979, almost three miles west of the McCargoe Campground. Immediately after the sinking, bodies were found as well as debris. The first mate had managed to make it to shore and built a crude shelter but still froze to death. (Jim Dan Hill Library, University of Wisconsin–Superior.)

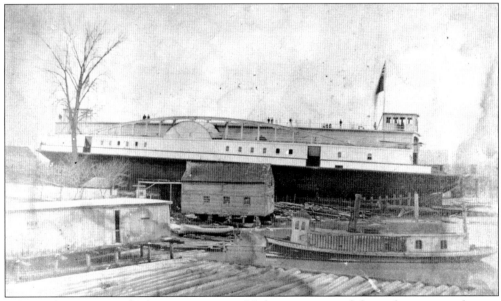

Of Canadian registry, the luxurious steamer *Michigan* was one of the earliest transit ships to visit Isle Royale on a regular schedule. As technology changed and the side-wheel steamers were surpassed for speed and luxury, the old ship ended up as a barge without power by 1886. Here it is undergoing that conversion in dry dock. It was ill-fated as a barge and sank with a load of iron ore off Point Sable on September 21, 1893. (Jim Dan Hill Library, University of Wisconsin–Superior.)

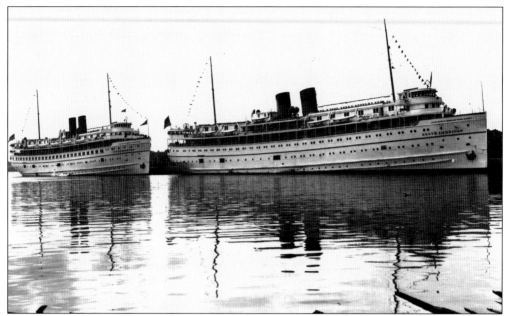

The Chicago, Duluth, and Georgian Bay Transit Company of Detroit sailed what have been acclaimed as two of the most beautiful ships on the Great Lakes—the *North American* and the *South American*. Built in 1913, the *North American* was 280 feet of elegance. The ships traveled the Great Lakes cruise ship style until the beginning of the jet age in 1963. It called frequently at Isle Royale for a short time on each cruise. (Jim Dan Hill Library, University of Wisconsin–Superior.)

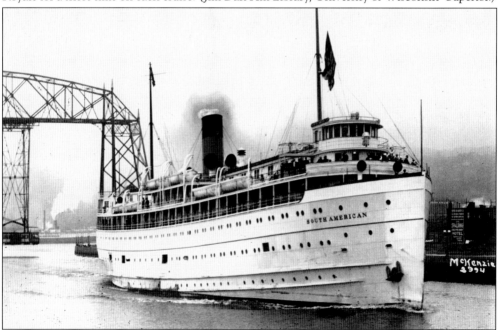

The *South American* was a year newer than its sister ship the *North American*, being launched in 1914. It sailed longer than the *North American*, being withdrawn from service in 1967 after the Montreal world's fair. People who worked on the island in the 1940s and 1950s said the visits of these ships were "short and hectic." (Jim Dan Hill Library, University of Wisconsin–Superior.)

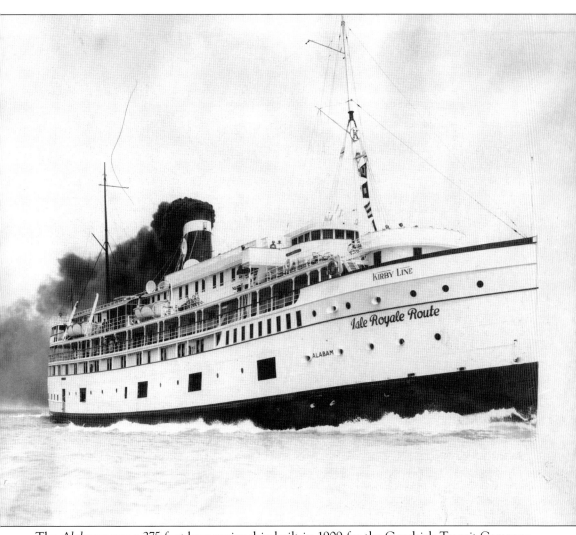

The *Alabama* was a 275-foot-long cruise ship built in 1909 for the Goodrich Transit Company of Chicago. Like the *North American* and the *South American*, it cruised the Great Lakes under eight different owners. The only owner that cruised consistently to Isle Royale was the Kirby Line, between 1937 and 1940, running between Detroit and Isle Royale and then on to Duluth. Note the Isle Royale Route slogan on the bow in this promotional postcard view. (Jim Dan Hill Library, University of Wisconsin–Superior.)

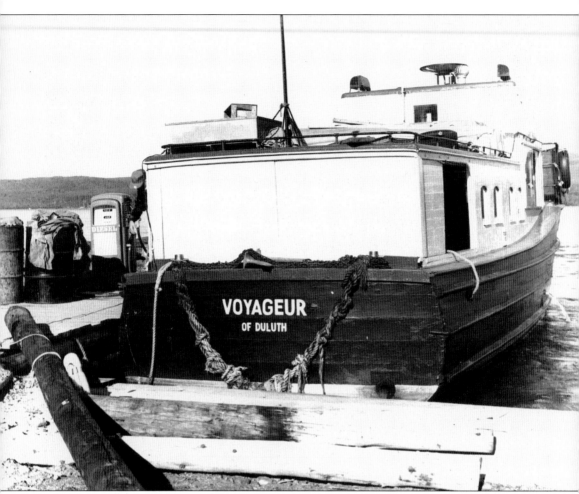

The 46-foot-long *Voyageur* was formerly called the *Copper Queen*. The vessel was built at Portage Entry in 1937 and served the island for many years out of Grand Portage Bay. It worked as a commercial fishing boat from 1937 until 1955. It then started a new career transporting visitors to the park. Here it is seen in 1976 as the *Voyageur* near the Grand Portage National Monument dock. (Jim Dan Hill Library, University of Wisconsin–Superior.)

Ever since Isle Royale National Park was formed, the National Park Service has maintained a small navy. The surplus World War I navy fleet launches *NPS 1* and *NPS 2* were assigned to serve the new park. Here they are docked side by side at the National Park Service headquarters at Caribou Island dock in 1939. (Isle Royale National Park Archive.)

The SS *Steechan* was designated an officers' yacht by the National Park Service and used for various VIP purposes in the early years of the park. This 1937 view shows this fine old "woodie" battened down for what looks like fall operations at the island. (Isle Royale National Park Archive.)

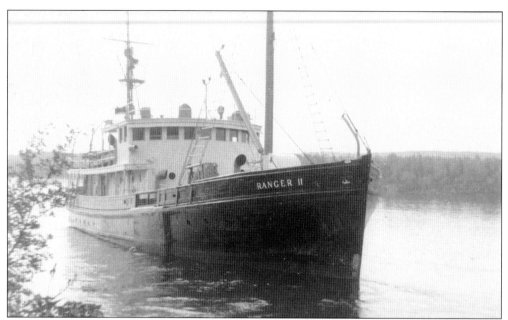

In 1951, the 114-foot-long U.S. Army *JMP-63* was transferred to the National Park Service. The boat was built in Stonington, Maine, in 1943 as a supply ship. It was refitted for passenger operations as the *Ranger II* and served the park until it was replaced by the *Ranger III* in 1958. It was retired in 1958 and transferred to the University of Michigan in 1962 and served for Great Lakes research until 1973. (Houghton County Historical Society Archives.)

In 1958, the *Ranger III* was put into service. The 165-foot-long *Ranger III* was built specifically for the National Park Service for Isle Royale in Sturgeon Bay, Wisconsin, in 1958 by the Cristy Corporation. With few modifications, it is still in service today. It has had thousands of successful sailings to the island and is the longest but smoothest crossing to the island. (Jim Dan Hill Library, University of Wisconsin–Superior.)

In the late 1940s, the first *Isle Royale Queen*, a converted fish tug (page 72), began making trips to the Isle Royale Rock Harbor dock from Copper Harbor. As the numbers of travelers who chose the shorter (although often rougher) boat trip to the island grew, the owner, Ward Grosnick, had the *Isle Royale Queen II* built in 1959 by T. D. Vinette Company of Escanaba. (Photograph by Eric Bonow; Jim Dan Hill Library, University of Wisconsin–Superior.)

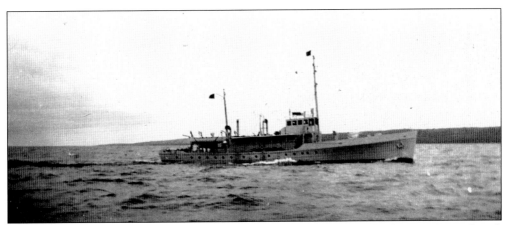

The waters around Isle Royale have been and continue to be patrolled by the U.S. Coast Guard. Here the U.S. Coast Guard cutter *Diligence* patrols off Point Houghton on Siskiwit Bay in 1937. (Isle Royale National Park Archive.)

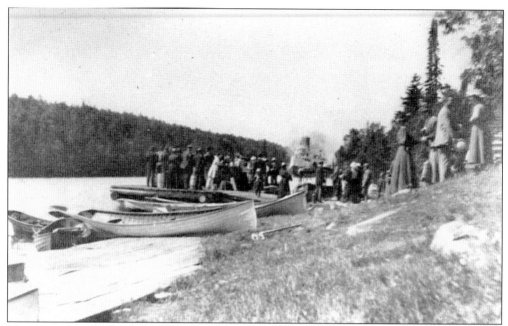

The ships that plied the waters to the copper mines, the fisheries, and the resorts were either passages of ease or uncomfortable and sometimes deadly for passengers over rough waters. Here a group of passengers awaits the SS *America* as it comes to the Tobin Harbor Minong Resort dock in 1908, ending or beginning another summer adventure on the "Royale Island." (Isle Royale National Park Archive.)

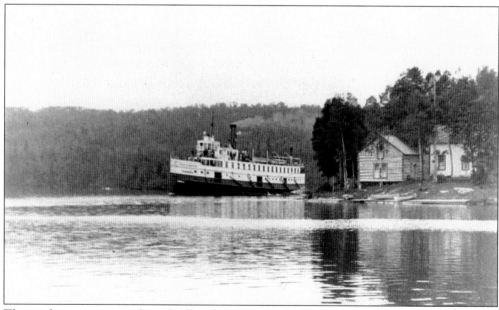

Those who grew up spending childhood summers at wonderful places like Matteson's Resort might have enjoyed the pungent smell of coal smoke and the echoing call of the brass steam whistle as the SS *America* came and left Tobin Harbor and the Minong Resort. However, those souls who were there, even as small children, are becoming a much smaller community, leaving photographs like this 1905 shot as the only memory. (Isle Royale National Park Archive.)

## Eight

# THE MAKING OF ISLE ROYALE NATIONAL PARK

In August 1935, the first members of Company 2699 of the Civilian Conservation Corps (CCC) arrived on Isle Royale, with the remainder of their company quick to follow. The CCC, made up of very young men, spent seven summers as the manpower that constructed much of the young park's infrastructure. They built the park headquarters on Mott Island, created boat campgrounds, and improved the few resorts that the park service had selected to retain. They also erected a fire tower and constructed miles of trails. By creating the CCC, president Franklin D. Roosevelt's goal was not only to put people to work but to improve federal parks and increase soil conservation in the process.

When these young men first set foot on this new national park, they were truly stepping into wilderness. This picture shows the tent camp set up to house the CCC enrollees. Later they stayed in barracks, but first they had to build them. (Isle Royale National Park Archive.)

Most of the buildings for the new park were built using logs harvested from the island itself. Here one can see, over a mile in the distance, stacked logs ready for use elsewhere on Isle Royale. (Isle Royale National Park Archive.)

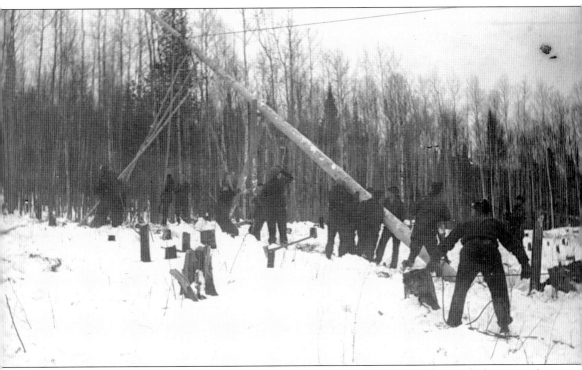

Isle Royale, isolated by Lake Superior, needed radio communication. To that end, the men of the CCC raised a radio tower, modernizing the park for the time and allowing visitors access to information from the mainland and employees access to information from around the island. (Isle Royale National Park Archive.)

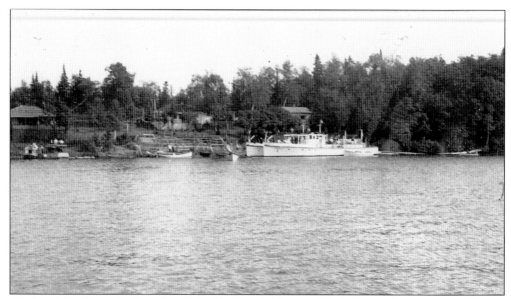

Caribou Island was the first site of the Isle Royale National Park Service headquarters. Here is the headquarters complete with a dock for the fleet that included *NPS 1*, later named the *Ranger*, and *NPS 2*, later called the *Beaver*. (Isle Royale National Park Archive.)

The *Beaver* was one of the original National Park Service ships. Here the skipper, Edwin C. Johnson, takes a moment to pose for a photograph. The rest of the *Beaver*'s crew were chief engineer Cuyler H. McCoy, first seaman L. B. Fitzsimmons, second seaman Omar Stocket, third seaman Bernard March, assistant engineer E. Francis Sparpana, and ship cook Ellis Mason. (Isle Royale National Park Archive.)

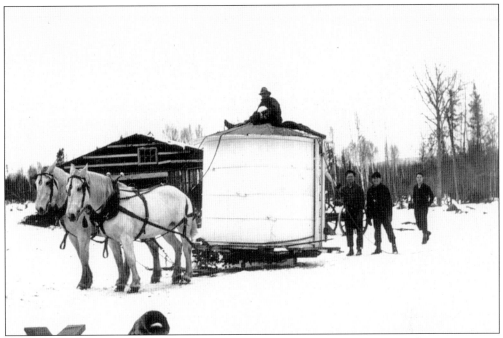

Although there are no horses on Isle Royale now, they truly were workers of the CCC camps. Here are two horses towing the water tower to its new location, which was atop a hill. (Isle Royale National Park Archive.)

The CCC was a government-run institution, so the camps were periodically visited by officials. This picture, taken on June 23, 1937, at Camp Rock Harbor, includes the camp educational advisor, the cook, the Emergency Conservation Work director, and the inspector. (Isle Royale National Park Archive.)

The future home of the Isle Royale National Park Mott Island administrative site is seen here in June 1938. The logs were towed from Camp Siskiwit in October 1937. (Isle Royale National Park Archive.)

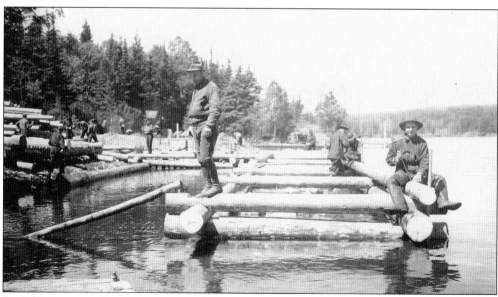

By July 10, 1938, the CCC enrollees have finished this rock-filled log crib for the low water section of the Mott Island administrative dock. As with anywhere on Isle Royale, the dock becomes the most important structure. Without it, getting supplies on land is very difficult. (Isle Royale National Park Archive.)

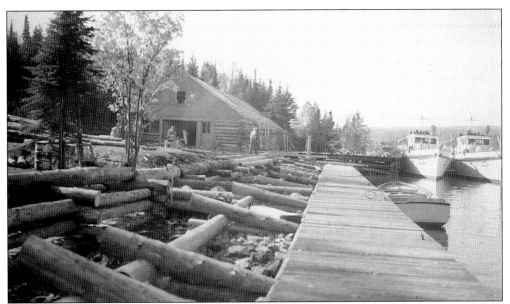

Comparing this photograph to the previous one, the work completed on the dock and the warehouse during the 1938 season is noticeable. CCC enrollees were used through September 27, and after that, a crew of six laborers and one skilled workman continued the work. (Isle Royale National Park Archive.)

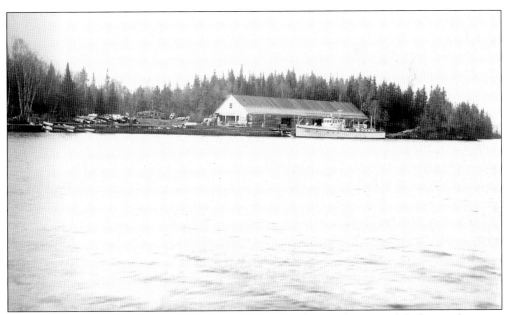

The stark contrast of the log piles seen in June 1938 to the warehouse and dock completion in October shows that the area was starting to take shape as the administrative site for the new park. (Isle Royale National Park Archive.)

Part of the reason 180 men spent the winter of 1936–1937 on Isle Royale was to reduce the fire hazard, in hopes a large fire could be avoided in the years to come. Here in the February picture they are burning brush for just that reason; however, the average snow depth was 39 inches. (Isle Royale National Park Archive.)

On July 25, 1936, a fire started near the logging camp at the head of Siskiwit Bay that eventually burned a large area of the camp before it jumped northward and consumed forest from Lake Desor to Moskey Basin. It continued until September when heavy rains helped the 1,800 firefighters, most of them CCC enrollees, extinguish the blaze. (Isle Royale National Park Archive.)

Here is a small section of the 27,000 acres of charred wasteland the fire left in its wake. In two months, over one-fifth of the island was turned to ash and burned logs; however, without the dedication of the CCC, more of Isle Royale's beauty may have been lost in the blaze. (Isle Royale National Park Archive.)

From the ashes comes a rebirth. This area of the 1936 burn shows the regrowth of fine weed and other annuals reaching a height of four to five feet by 1939. Nature has a way of healing itself. (Isle Royale National Park Archive.)

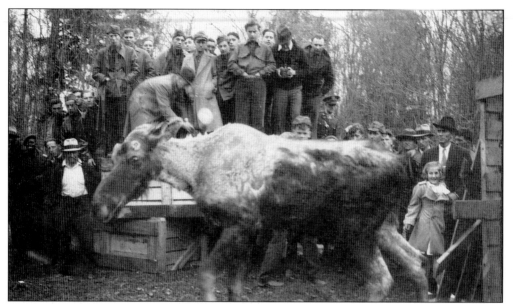

A crowd gathers near Munising to watch the release of an Isle Royale moose. What a spectacle it must have been to see these large creatures emerge from their crates looking confused but able to run away. (Isle Royale National Park Archive.)

The task of relocating moose called for some old-fashioned cowboy skills. In order to relocate moose, they first had to be caught and kept from running away. It is strange to see moose trapped in a corral awaiting relocation. (Isle Royale National Park Archive.)

Of course once these moose were corralled, they had to be fed. Again the men of the CCC used methods similar to that on a farm. Here a moose is eating from a trough, much like a horse or cow, but the food of choice for the moose is balsam fir, so this trough is filled with balsam and a variety of other coniferous tree branches. (Isle Royale National Park Archive.)

Taking care of the moose may have been a welcome task for some of the enrollees. Here is one man feeding a moose just as one would feed a horse through a fence. After being cared for by humans for a while, these moose had to readapt to life in the wild. (Isle Royale National Park Archive.)

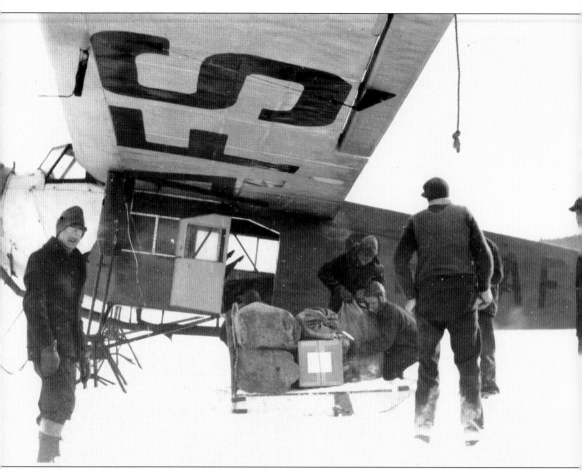

Imagine how welcoming the site of this Canadian plane was for those "hardy boys." On board was mail; letters from home must have been wonderful to read on the long, cold evenings of that Isle Royale winter. (Isle Royale National Park Archive.)

The mess hall tables are set to serve another hearty meal. Getting supplies to the island was not the only issue faced by those feeding these men. Apparently storing the food was difficult as well. Note the boxes stacked against the walls. (Isle Royale National Park Archive.)

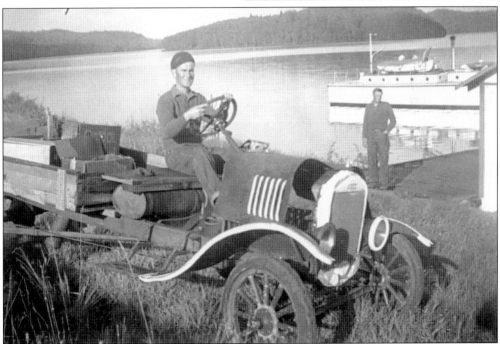

Although cars are not allowed on Isle Royale National Park today, this old steamer car must have been put to good use in the early days of the park, transporting building materials and supplies. (Isle Royale National Park Archive.)

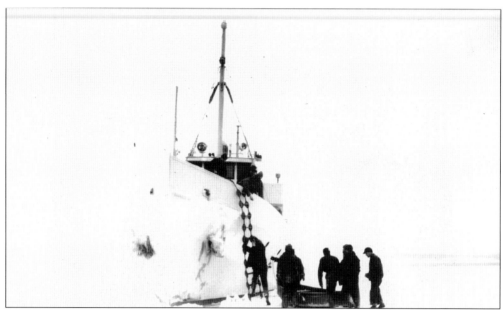

The men may have felt left alone in the frozen wilderness, but they were not forgotten. Here on January 11, 1937, the U.S. Coast Guard cutter *Crawford* arrives in Siskiwit Bay. The six-inch-thick ice did not keep it from delivering the mail and supplies the men were waiting for. (Isle Royale National Park Archive.)

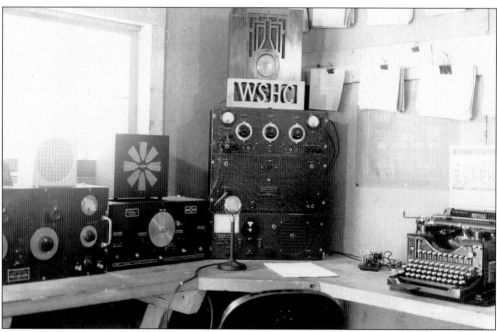

This WSHC radio station at its new location on Mott Island proved very satisfactory. More radio traffic was handled during August 1938 than any month prior in the history of Isle Royale. Messages were handled for park visitors to and from the mainland and from Mott Island to other locations in the area. (Isle Royale National Park Archive.)

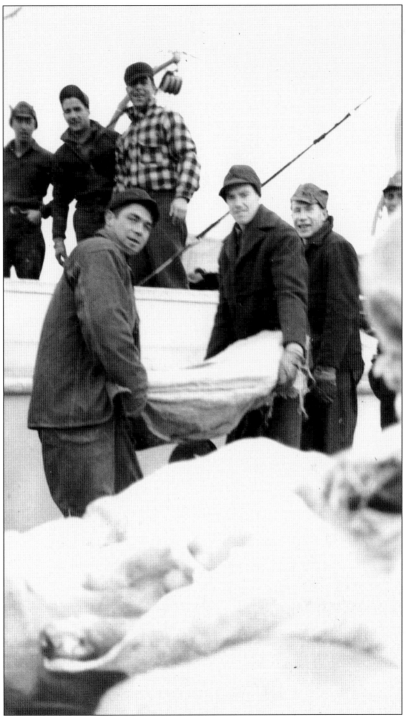

The boxes and bundles of supplies were handled many times before these hardy boys could enjoy what was included. It was most certainly hard work, but they seem happy to be doing all that heavy lifting. It must have been nice to have the security of knowing they were not forgotten out there. (Isle Royale National Park Archive.)

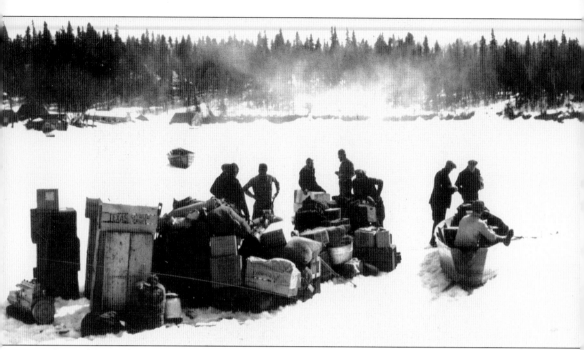

Once the supplies were unloaded from the ship, the men then had the task of getting all the boxes, as seen here, from the ice-covered bay over to their camp. They piled the supplies into the skiffs before dragging and pushing the skiffs across the ice to shore. (Isle Royale National Park Archive.)

Snowshoes must have been so important for getting everywhere on the island. With average snow depths over three feet high, not only were they needed if the men ventured off the beaten path, but some days they may have been needed to get just about anywhere in the morning. (Isle Royale National Park Archive.)

The men worked on a variety of projects throughout that winter. Here is the hustle and bustle around the camp while some work on the roof of barracks No. 1. The team of horses can be seen off to the right. (Isle Royale National Park Archive.)

The Mott Island footpaths, like the one pictured here in 1938, were constructed by the CCC through the deep woods to provide accessibility to and from buildings and facilities. (Isle Royale National Park Archive.)

In 1939, work continued at the administrative site. The roof on warehouse No. 1 is completely shingled, and warehouse No. 2 has its log work completed and ready for the frame, the roof, and the doors. (Isle Royale National Park Archive.)

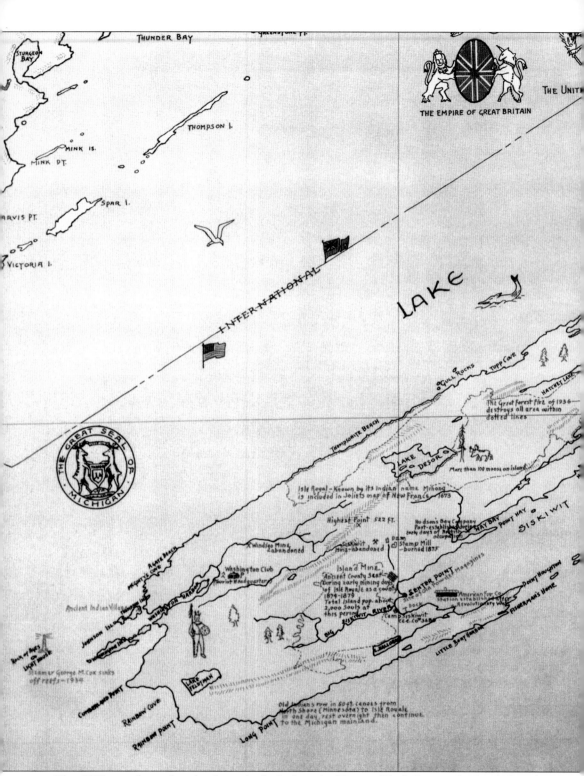

This 1939 map shows the island as it looked when the National Park Service finalized plans for this new park. Note all the resorts are still listed as well as the old mining sites. Also of interest

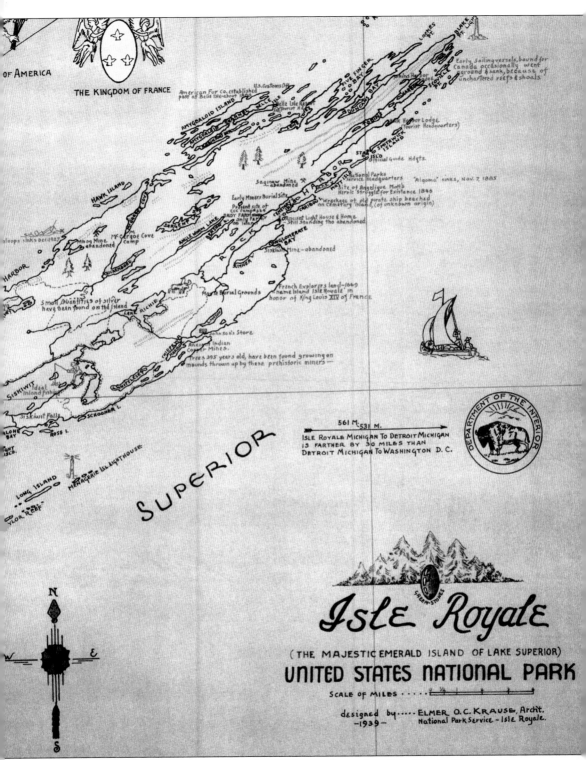

is the outline of the areas destroyed by the 1936 great forest fire. (Isle Royale Natural History Association and Isle Royale National Park Archive.)

This picture of Residence E, taken on October 10, 1938, shows it nearly completed. The stone foundation was installed during the 1939 season. Also seen are the log steps leading from the dock to the hall, which is a common construction on the island. (Isle Royale National Park Archive.)

Here some of the Isle Royale CCC enrollees pose for a group photograph. For these young men, most from urban areas, Isle Royale was their first taste of wilderness. Imagine what it was like, alone in the wilderness with the mosquitoes. They did their job by laying the groundwork for the preservation of this island wilderness for future generations. (Isle Royale National Park Archive.)

# ACROSS AMERICA, PEOPLE ARE DISCOVERING SOMETHING WONDERFUL. THEIR HERITAGE.

Arcadia Publishing is the leading local history publisher in the United States. With more than 3,000 titles in print and hundreds of new titles released every year, Arcadia has extensive specialized experience chronicling the history of communities and celebrating America's hidden stories, bringing to life the people, places, and events from the past. To discover the history of other communities across the nation, please visit:

# www.arcadiapublishing.com

Customized search tools allow you to find regional history books about the town where you grew up, the cities where your friends and family live, the town where your parents met, or even that retirement spot you've been dreaming about.